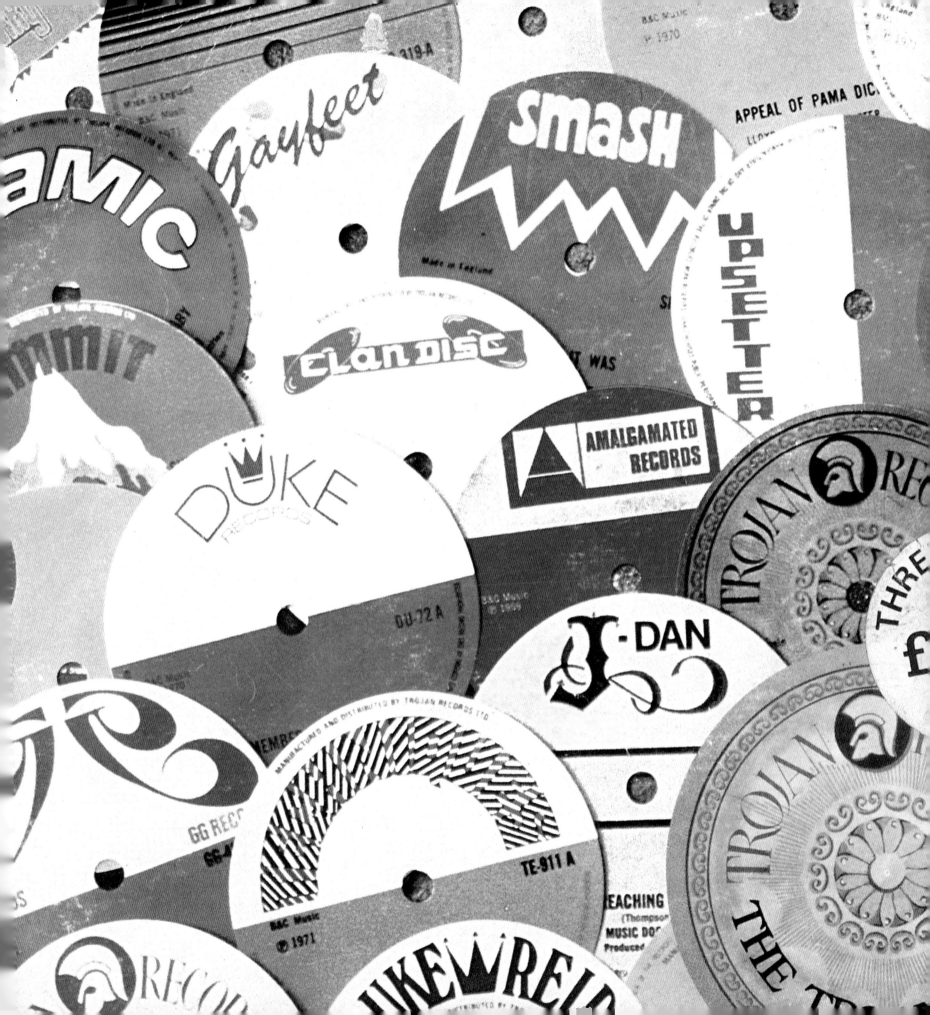

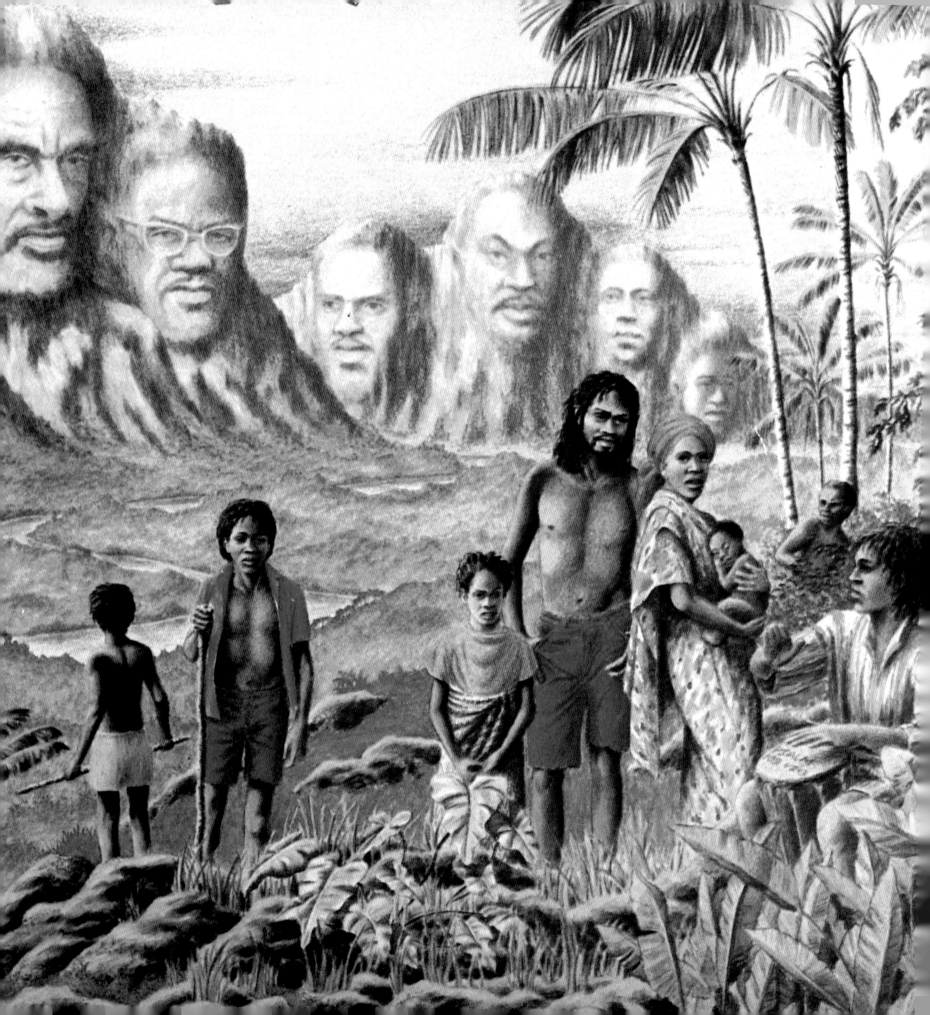

STIR IT UP

reggae album cover art

by Chris Morrow

CHRONICLE BOOKS

SAN FRANCISCO

Dedicated to God, and William, Judi, and Suzie Morrow.
CM

Page 1: **TROJAN STORY**
Various artists
Trojan | 1971 | Cover design: Dave Fields

Page 2: **TRIBUTE TO THE MARTYRS**
Steel Pulse
Mango | 1979 | Cover illustration: Jane Hawkins

First published in the United States in 1999 by Chronicle Books
First published in the United Kingdom in 1999 by Thames & Hudson Ltd., London

Printed in Singapore

Library of Congress Cataloging-in-Publication Data
Morrow, Chris.
 Stir it up : reggae album cover art / Chris Morrow.
 p. cm.
 Includes index.
 ISBN 0-8118-2616-3 (pb)
 1. Sound recordings—album covers—United States.
 2. Reggae music—Pictorial works. I. Title.
 NC1882.7.R44 M37 199
 741.6'6—dc21 99-31751 CIP

Cover design: Shawn Hazen

Distributed in Canada by Raincoast Books,
8680 Cambie Street
Vancouver, BC V6P 6M9

10 9 8 7 6 5 4 3 2 1

Chronicle Books
85 Second Street
San Francisco, CA 94105

www.chroniclebooks.com

ACKNOWLEDGMENTS
*Extra special thanks to Ellen Nygaard for creating the original design concept
for this project and for her tireless work on the dummy. Also special thanks to
Paul Gottlieb and Thomas Neurath for their encouragement and support.*

*I would like to thank the following people without whose assistance this project
would have proven impossible: Larry Adamo, Toula Ballas, Lloyd Bradley, Julio
Bravo, Rob Chapman, Barney Coxe and the 82 Penton Place Posse, Isaac Green,
Eric Himmel, Ray Hurford, Ira Heaps and Nadine at Jammyland, Jason Levine,
John Masden, Tony McDermott, Charlie Morgan, Palm Pictures, Maya Perez,
Chris Prete, Nick Scharlatt, John Vitelli, Tony Wright, JWL & JHR. A special salute
to Dro, for sharing his unparalleled collection of reggae LPs. Of course, respect
to Neville Garrick, for all his insight and encouragement.*

*Thanks to Barney Coxe, Abby Gennet, Michele La Rocca, and Trevor Scotland
who took most of the photographs for this book. And thanks to Adrian Boot
whose photographs appear on pages 9, 14 (above left and right), 24–5 (back-
ground); covers photographed by Adrian Boot from his collection are on pages
84 (above), 91 (top), 92 (below left and right), 101 (top left).*

*Thanks as well to the record shops who generously lent many of the album
covers illustrated in the book: Ernie B's Reggae, El Dorado Hills, CA; Honest
Jon's, London; Intoxica, London; Jammyland, New York City; Rocket Scientist,
New York City.*

*And thanks to the record labels, without whom this book could not have
happened:*
*ABC-Paramount, Ace Of Clubs, African Museum, ALA, Alligator, A&M, Aquarius,
Ariwa, Atlantic, Ballistic, Big Shot, Black Ark, Blood & Fire, Black Roots, Blue
Beat, Burning Sound, CBS, Channel One, Clappers, Clocktower, DIP, Dread At
The Control, Dynamic, Elektra, EMI-Capital, Empire, Joe Gibbs Music,
Greensleeves, Grove Music, Heartbeat, Hit Bound, Incredible Music, Island,
Jackpot, Jam Rock, Jammys, J&L, Jumbo, Justice League, K Records, Kentone, Klik,
Live and Learn, Mango, Message, Micron, Nighthawk, Original Music, Pama,
Pipe Music, Platinum Express, Power House, Ras, RCA, Rocky One, Rockers
International, Serious Gold, Shanachie, Solomonic, Sonic Sounds, Studio One,
Sun Plum, Tamoki/Wambesi, Third World, Treasure Isle, Trojan, Tuff Gong,
Ujama, Upbeat, Vista Sounds, Virgin, Vulcan, Weed Beat.*

*Every possible effort has been made to locate and credit copyright holders of the
material reproduced in this book. The author and publisher apologize for any
omissions or errors, which can be corrected in future editions.*

CONTENTS

FOREWORD *by Neville Garrick*

They say a picture is worth a thousand words, but it really depends on whose words you try to picture.

During the turbulent '70s and the eventful '80s, I had the opportunity and challenge to interpret visually the powerful words of Bob Marley, Peter Tosh, Bunny Wailer, and other reggae icons. Reggae was the newest music form to be incorporated into pop music's culture, which made my task in marketing these concepts to a new international audience even more challenging. Armed with a First World training in graphic design and marketing at UCLA (University of California at Los Angeles) and cultivated in the Hollywood environs, I returned to the so-called Third World island of Jamaica to use my skills to project the dynamics and truth of reggae. This music had become the soapbox voice of the underprivileged and oppressed Jamaicans who had no other means of expressing their experience and lifestyle. According to Bob Marley, reggae music was like the news—the poor people's newspaper. Ironically, before teaming up with Bob Marley, I was employed by the establishment newspaper the *Jamaica Daily News* as the editorial artistic director.

After several encounters with Bob Marley and my personal embracing of the Rastafarian faith, I resigned from the *Daily News* to spread the reggae news. With Jah and the colors of the Ethiopian banner in mind, I began to color the music. In the next fifteen years (1975–90), I created over one hundred record jackets for various international and local reggae recording artists. The greatest challenge was always to condense all these potent lyrics of spirituality, love, and protest into a singular two-dimensional image that somehow reflected the music inside the 12" x 12" frame of a record jacket. However, this small space became my canvas and window to introduce reggae visually to the world.

One of the earliest covers I created was for an album entitled *Rastafari* by Ras Michael & The Sons of Negus, graphically featuring the image of Ras Tafari at age seven. From 1975 onwards I worked exclusively for the Wailers as Tuff Gong's art director, designing record labels and album covers primarily for Bob Marley, Peter Tosh, Bunny Wailer, and the I-Three. I enjoyed working with these artists, as I was designing covers for concept albums as opposed to a bunch of tunes put together to make an album. I could also be more artistic, using a variety of media to represent the image or the idea that the recording artist was trying to convey instead of just a photograph of the singer. The title of the album dictated the direction I took in expressing the idea. Sometimes I had a part in choosing the title, and being around while the music was created also gave me an inside track to its interpretation. The sound and powerful lyrics that came from the likes of Bob Marley and Peter Tosh was enough of an inspiration to create covers dealing with African affairs (like Bob Marley's *Survival*), with world affairs (like Peter Tosh's *No Nuclear War*), *Confrontation* (a tribute to Bob Marley depicting him as the Ethiopian St. Giorgis, or St. George in the final conflict when the good overcomes evil), and other spiritually and politically influenced albums. As the artists' popularity grew and reggae made its invasion into pop music, the record shops of the world became my gallery.

In reminiscence, Bob Marley's most politically charged album, *Survival* (originally called *Black Survival*) was of one of my biggest challenges. Unfortunately, this album was the least promoted by the record company, and although an attractive poster based on the album art, including titbit information about each African state, was produced in the USA, it was never distributed as intended to high schools. Arriving in Kenya, en route to the Zimbabwe Independence ceremony, I was greeted with kisses by a woman at the Nairobi airport who was excited that the Kenyan flag was the first African flag on the *Survival* artwork. That album cover was definitely one of my favorites.

Being an associate, and sometimes friend, of the artists for whom I created album covers had its advantages and disadvantages. It was very positive to share a common view of Africa, the politics of the Third World, and other ideologies towards the upliftment of my people with the artists whose covers I designed while at Tuff Gong. With the occasional exception

of Bunny Wailer and Peter Tosh, the visual concepts of the cover art was left entirely up to me. I ran into some problems, however, with my first opportunity to design a Bob Marley record cover. Bob, impressed by my cover for Bunny Wailer's *Blackheart Man*, asked me to do *Rastaman Vibration*. Without any guidelines, I conceived Bob's face as the map of Africa surrealistically floating against a cloudy blue sky, with the Rasta colors of green, gold, and red representing the covenant rainbow around Africa. An image of a lion facing east was placed in the area of Ethiopia. This was my symbolic impression of the title *Rastaman Vibration*. Everyone in the group liked the painting, but I later found out that Bob had a problem with it. This was also the occasion of my first meeting with Chris Blackwell, president of Island Records. Chris, who was in Jamaica for two days to hear the album's tracks and take the album art to London, had also seen and liked the painting. But Bob said it looked too much like *Blackheart Man*, and he wanted it to be different. I personally could not see the similarity, except that it used the same Rastafarian symbols, the lion image, for instance, and head shots of the two Rastamen, Bob and Bunny.

I had less than twenty-four hours to come up with a new idea, finish it, and have the artwork approved. This was real pressure. In those days I used to live at 56 Hope Road, Kingston, Bob's headquarters, in a two-room cottage at the back of the great house. While searching my mind for new ideas, I began to watercolor a faded photocopy of a picture I had taken of Bob at one of our early meetings while I was still working for the *Daily News*. After coloring this image of Bob in a contemplative mood, I cut it out from the background and pasted it on a piece of burlap material. Burlap symbolized the sackcloth of the Rastaman's tradition, and I had been using burlap instead of canvas as a medium for my paintings. I later used burlap as the base material for most of the backdrops I created for live concerts around the world. While I was checking out this artwork in the rough, and still searching for ideas, Bob happened to pass by my cottage and glimpsed the artwork through the window. I don't know how long he was checking it out, but with a sudden exclamation Bob shouted, "Ah! The album cover that!" Here began the history of my creations of album art for one of the most important and popular music icons of the century.

The painting that Bob rejected for *Rastaman Vibration* was stolen later that year from my exhibition called "Taking Art to the People." The idea of using the outline of the map of Africa as the focal point to project the Rastafarian theme was used by several album cover designers in later years. The images of H.I.M. Haile Selassie and Marcus Garvey also became standard icons of Rasta record art.

The inclusion of Bob Marley's powerful lyrics on nearly all his album sleeves had a tremendous impact on his international audience, we later found out. While on tour in Tokyo in 1979, we were surprised to see that the Japanese audiences sang all the words along with Bob. We learned that the only English they knew was the words printed on the record sleeves.

Marley didn't write throw-away lyrics, so it was very important to him that his audience understood every word that he was saying and not just rocking to the beat. After all, Marley's fan base at the time was mainly white college kids and hippies, not the converted. As art director I also created backdrops and stage lighting to enhance the message—what I called coloring the music.

As a positive result of the message, Bob is now regarded as the voice of the oppressed, regardless of their race, religion, or language. I am very thankful to have contributed to such a spiritual movement of peace and love which still impacts on today's generation. Working as Tuff Gong's art director gave me the opportunity to use this medium to make social comments about Jamaica and the world. Designing record covers during the protest era of reggae music was a perfect vehicle for my militant expressions. The album cover *Earth Crisis* that I designed for the English reggae group Steel Pulse typifies what I called social-commentary art. Most of the international reggae album covers created outside Jamaica were designed by record companies' art departments and independent design studios in London and New York. There was hardly any contact with the performers, who usually accepted whatever the record company delivered.

I congratulate Chris Morrow for this book that recognizes the importance of reggae album art in the impact and popularization of the music globally.

Words like SURVIVAL, EXODUS, CONFRONTATION are so powerful, maybe they need a thousand pictures to illustrate them. It really depends on whose words you try to picture.

INTRODUCTION

The golden age of reggae album cover artwork was the period from the early '60s to the mid-'80s. Reggae sleeves provided the visual support for a revolutionary sound which captivated the imagination of the music world. Yet while other elements of reggae culture—including its beat, politics, and religion—were readily acknowledged, the role of reggae's cover artwork in spreading that culture has been slower to gain recognition. Tony Wright, for many years a designer and illustrator for Island Records, remembers being profoundly impressed by the political and spiritual conviction of the reggae musicians he worked with. Yet, although Wright had created sleeves for such respected reggae acts as Bob Marley, Black Uhuru, and Ijahman Levi, he felt he was working on "underground" covers, covers ignored by mainstream audiences. Since reggae's sleeves were so pronounced in expressing a culture and lifestyle alien to most non-Jamaicans, it was only natural to expect them to be overlooked. So it was with a pleasant sense of surprise that Wright began to notice the influence of reggae cover art on the albums of established rock acts such as The Clash, Elvis Costello, and The Police. This impact was confirmed for Wright when he was approached by Bob Dylan with the request: "Can you help me get that reggae look for my cover?"

The look that these rock stars wanted was one that reggae fans had been enjoying for years. It seemed to effortlessly blend politics and religion, fashion and social protest, humor and outrage. Reggae's sleeves were among the most politically strident and culturally conscious that pop music has ever produced, and carried the music's most radical messages, addressing weighty topics like Rastafarianism, Pan-Africanism, political corruption, and nuclear war. They have also reveled in reggae's lighter and celebratory side, with pictorial tributes to American Westerns, steamy dances, and blazing spliffs. Yet, despite the international respect reggae enjoyed musically, reggae album covers have rarely, apart from Bob Marley's LPs, received serious recognition. It is the aim of this book to shed light on the genre and bring the true significance of the cover art into focus.

Reggae cover art's development into such an expressive medium is remarkable considering its haphazard origins. The Jamaican music industry of the '60s and early '70s was a hornets' nest buzzing with constant squabbles between producers, singers, and musicians over rights and money. Designing album sleeves was often an afterthought. It was not unusual for a record to be recorded and released to the public within the same week, making it necessary for the early designers to work fast and inexpensively if they wanted to make a living. In addition, long-playing records were slow to catch on in Jamaica where the 7" single was historically the record of choice. LPs were more expensive to produce and, unlike the 7" singles, could not be played in the nation's ubiquitous juke-box machines. Reflecting this lack of attention, the early cover designs for Jamaican ska and rocksteady LPs were content to mimic the style of the popular American rhythm-and-blues covers. They were also often cheaply produced—some of the early jackets released from Coxsone Dodd's legendary Studio One label were printed on the reverse of Lipton Pronto Teabag cartons, while another recycled a Selsun anti-dandruff poster.

By the late '60s, many Jamaican producers were taking their recordings to England, where they licensed tracks to British labels like Island, Pama, and Trojan.

The recording artists themselves rarely had any knowledge of these transactions and were even less frequently paid for their work. The story goes that Jamaican DJ Big Youth walked into Trojan's London office and caught sight of the cover for *Version Galore* (which featured a Warhol-like treatment of his face). He asked, "What album is that? I've never seen it before."

The early British covers were largely light-hearted, many featuring scantily clad women rather than the musicians recorded. Some, however, like Clancy Eccles' *Freedom*, foreshadowed the spirit that would be the signature of roots covers of the '70s. In fact, it was soon clear that authentic representations of reggae culture, not R & B take-offs or platinum-haired pin-ups, would be the images that would help break reggae across the world.

That break was fueled in no small part by the albums produced at London's Island Records for Bob Marley. It was Island boss Chris Blackwell's innovation to conceive the first true reggae albums, albums that bore a conceptual identity rather than just being a collection of singles like previous Jamaican and British releases. Blackwell had worked with such established rock acts as Traffic and Jethro Tull, and understood the importance of album covers in promoting a record. Determined to give Marley's sleeves all the trappings of a rock album, Blackwell commissioned covers for Marley that would be regarded as reggae's highpoint for production value and artistic complextiy. More importantly, not only were Marley's covers sophisticated in their packaging and presentation, but they were unflinching in depicting his Rastafarian beliefs. While not every British or Jamaican label could afford the type of production and the time that Island put into Marley's covers, they could make sure their sleeves represented the cultural attitudes of their artists.

From the West Indian neighborhoods of London to the college campuses in America, images celebrating a proud and complex culture were being discovered by eager fans. While the Jamaican government was trying hard to create an image of Jamaica as a tourists' paradise, reggae culture was equally adamant in bringing its own world to international attention. As reggae's popularity soared, its designers sensed that their covers represented a unique opportunity to reach a previously elusive yet influential audience. But despite the praise accorded to well known designers like Neville Garrick and Tony Wright, reggae album cover art has never received proper credit for its impact and influence.

This volume showcases some of the major themes found in reggae cover art, themes that were often carried over reggae's different musical phases. It also features many albums that are not quite so easily categorized, hardly a surprise given reggae's eclectic nature. When the first of these LPs began to trickle out of Jamaica over twenty-five years ago, it is doubtful that many could have foreseen the huge influence that they would eventually wield. But today they stand as a graphic testament to reggae's greatness. As reggae rose to become one of the most popular musical styles in the world, these covers were at the front line, visually announcing the arrival of a culture whose sounds would reverberate for years to come.

Opposite: Lee Perry's Black Ark Studio, Kingston, Jamaica

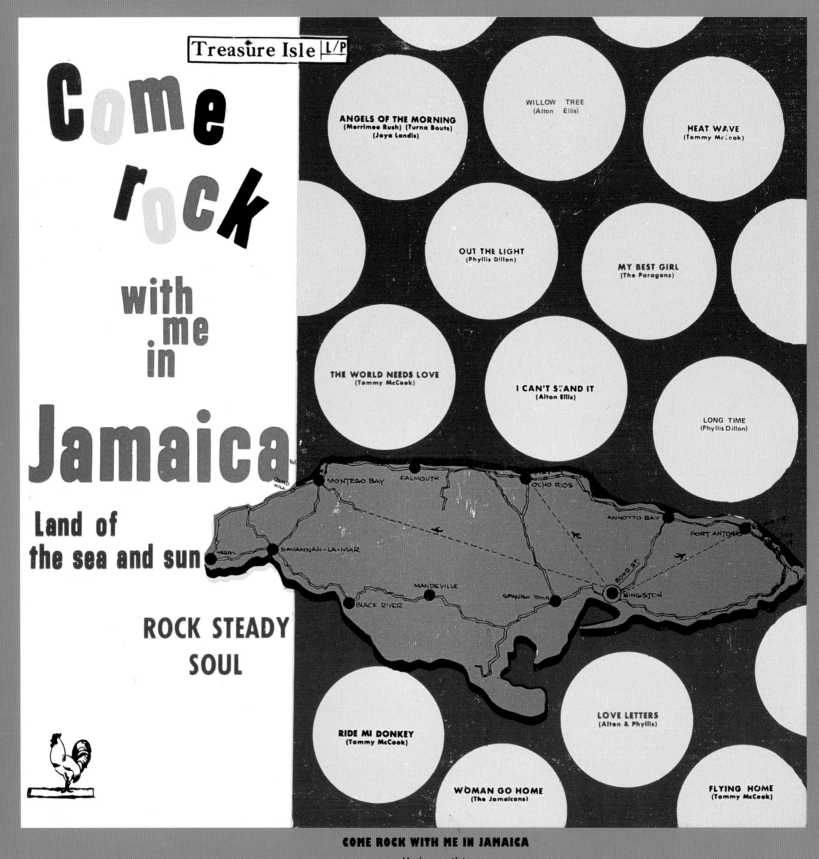

COME ROCK WITH ME IN JAMAICA

Various artists

Treasure Isle | c. 1969

ISLAND OF JAMAICA

As with the Mississippi delta and the blues, or Brazil and the samba, Jamaica and reggae—the place and the music—will be forever linked. Jamaica gained independence from Britain in 1962, and reggae's rise during the subsequent years was characterized by a fierce sense of pride and loyalty towards the island. The bond between the music and the nation was evident through the many reggae LPs that featured images of Jamaica on their covers. Covers like *Come Rock With Me in Jamaica* or Prince Buster's *Ska-Lip-Soul* employed the popular device of presenting the island in outline form as it would appear on a map. Other albums featured photos of Jamaica's natural beauty or scenes from Jamaican life. Don Carlos's *Ghetto Living* made the connection between land and politics, suggesting that the roots of Jamaica's ghetto existence lay in the exploitative plantation system that had historically dominated the island. Indeed, reggae covers' constant allusions to Jamaica helped insure that, even as the music later gained popularity across the globe, it would always remain linked to its island roots.

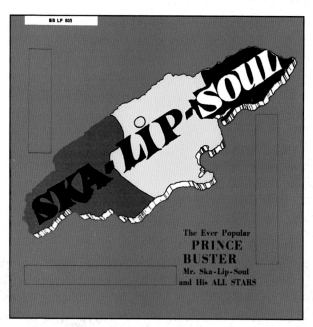

SKA-LIP-SOUL
Prince Buster All Stars
Blue Beat | *c.* 1966

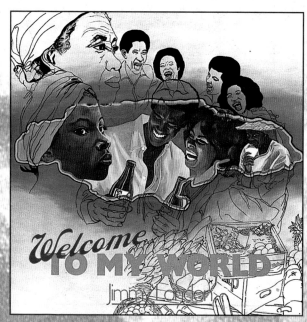

WELCOME TO MY WORLD
Jimmy London
Burning Sounds | 1979 | Cover illustration: Earl Neish

Background: detail from **GHETTO LIVING**
Don Carlos and Gold
Tamoki/Wambesi | *c.* 1982

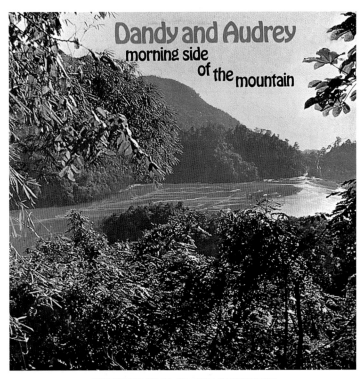

MORNING SIDE OF THE MOUNTAIN

Dandy and Audrey

Trojan | 1970 | Cover design: CCS Advertising

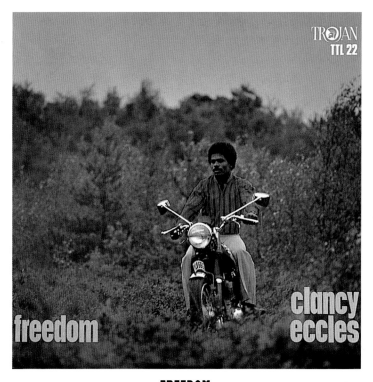

FREEDOM

Clancy Eccles

Trojan |1969 | Cover design: CCS Advertising

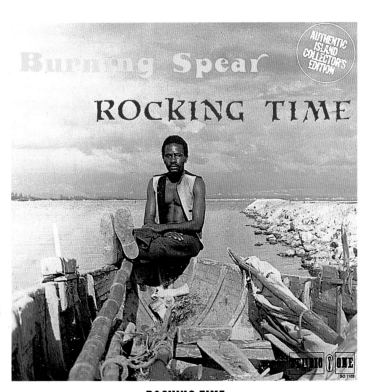

ROCKING TIME

Burning Spear

Studio One/Buddah | 1976

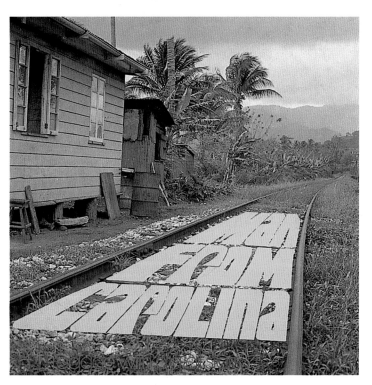

MAN FROM CAROLINA

Various artists

Trojan | 1970 | Cover design: CCS Advertising | Cover photo: Ged Grimmel

JAMAICA TODAY—THE SEVENTIES

Various artists

Studio One | 1971

Jamaica Today

THE
SEVENTIES

STEREO

CSL 8022

SKA, ROCKSTEADY, AND EARLY REGGAE

The covers of ska, rocksteady, and early reggae albums were heavily influenced by American rhythm and blues. This is understandable, as R & B had been a major staple of the Jamaican musical diet since the early '50s. Popularized by radio broadcasts reaching Jamaica from Miami and New Orleans, as well as by migrant workers returning from the USA armed with records by the likes of Big Joe Turner, Louis Jordan, and Fats Domino, American R & B became a major musical presence in Jamaica. R & B would even help bring about the birth of the Jamaican recording industry, as sound-system operators who could no longer afford the astronomical prices of imported American records reasoned it would be cheaper to record homegrown talent doing R & B standards. By the mid '60s, however, Jamaican artists were no longer simply imitating US styles, but had created a distinctly Jamaican sound known as ska.

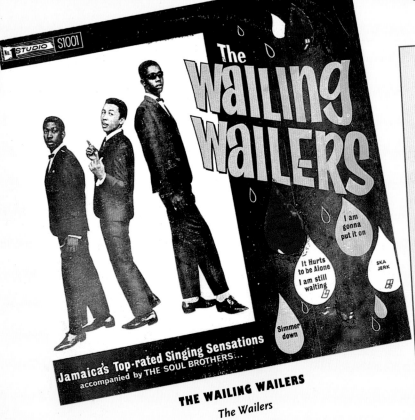

THE WAILING WAILERS
The Wailers
Studio One | 1965

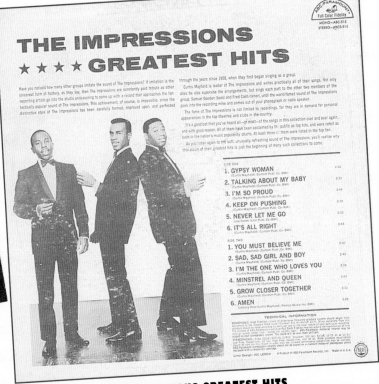

THE IMPRESSIONS GREATEST HITS
The Impressions
ABC Paramount | *c.* 1971 | Back cover design: Joe Lebow

ROCKSTEADY EXPLOSION
Byron Lee and the Dragonaires
Dynamic | *c.* 1968 | Cover design: Derek Hamilton

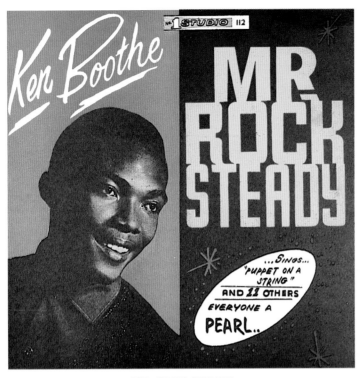

MR. ROCK STEADY

Ken Boothe

Studio One | 1968 | Cover design: Roy Tomlingson

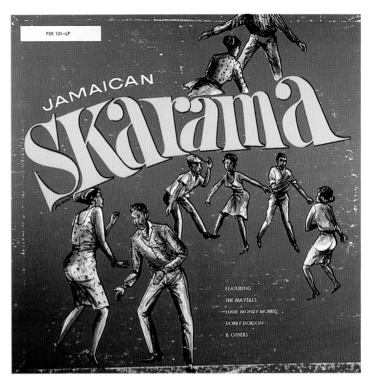

JAMAICAN SKARAMA

Various artists

Kentone | 1965 | Cover design: Joe West

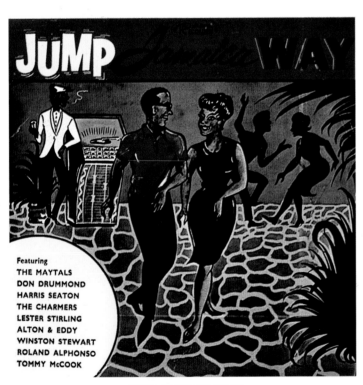

JUMP JAMAICA WAY

Various artists

ND Records | 1963

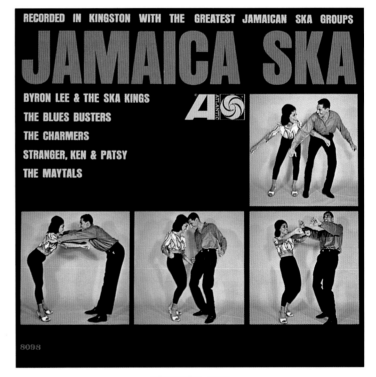

JAMAICA SKA

Various artists

Atlantic | 1964 | Cover design: Loring Eutemey

Ska reflected a complex blend of musical influences, the most obvious being mento, Jamaica's rural folk music. Like ska, mento itself had developed from diverse traditions, incorporating not only the African-derived sounds of Pocomania and Revivalism, but also European styles like the quadrille. In mento lay the foundation for the quick shuffle beat that was later a signature of ska, but for the many Jamaicans who by the '40s and '50s had migrated from the country to the island's urban centers, mento carried the stigma of an old-fashioned music, too closely asociated with Jamaica's rural lifestyle—they preferred R & B. Ska soon became the music of choice for urban Jamaicans, successfully incorporating mento with American R & B, as well as calypso and Latin-inspired horns, all melted into a unique pulsing beat. Lyrically and musically the new sound known as ska (supposedly after the sound made by the style's choppy guitar chords) foreshadowed the religious and social attitudes that would later characterize reggae. Yet despite the distinctly Jamaican innovations central to the music, the album covers from this period seemed unwilling to cut the umbilical cord from American R & B.

If these early covers are any indication, the nascent Jamaican labels never suspected reggae would become an international "rebel" music. They were satisfied to clean up Kingston's ghetto music and market it to the USA as another dance sensation, like the twist or the cha cha. This strategy is evident on the cover of *Jamaica Ska*, a compilation issued by Atlantic in 1964. The album was made to support a delegation of ska artists sent that year to the World's Fair. The troupe was headlined by Millie Small to capitalize on the huge UK success of her ska single *My Boy Lollipop*, which went on to sell over six million copies. She and other "wholesome" ska acts (no Rastafarians) were sent on tour to plant the seeds for a ska dance craze in the USA. This was organized by Edward Seaga, then Jamaica's Minister of Culture and later the island's Prime Minister. Although there was never really any step in Jamaica known as the ska, the album's cover nonetheless features a smiling, clean-cut couple giving step-by-step instructions on how to "Dance the Jamaica Ska."

R & B styled covers remained in vogue, and the sleeves for labels like Coxsone Dodd's Studio One often presented artists in the matching suits and frozen poses characteristic of American soul. The image of the teenage Wailers on the cover of *The Wailing Wailers* unabashedly mimics their American idols The Impressions, while *Presenting Jamaican All Stars Vol. 1* has the feel of an early Apollo revue. This trend is seen most clearly in the compilation *This is Reggae*, which copies the American soul compilation *This Is Soul* almost completely.

By the end of the '70s the clean, R & B inspired covers typical of early releases were gradually eclipsed by the strident, politically charged sleeves that accompanied roots reggae. Ironically, it was international audiences who forced this change, as labels increasingly catered to the rock crowd's fascination with Rasta symbols like dreadlocks, spliffs, and Haile Selassie.

THIS IS SOUL

Various artists

Atlantic | *c.* 1968

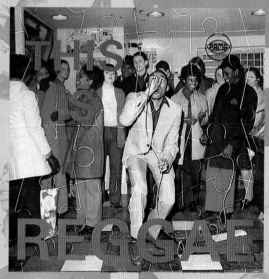

THIS IS REGGAE

Various artists

Pama | *c.* 1969

Background: **HOT SHOT**

The Soul Brothers

Coxsone | 1967

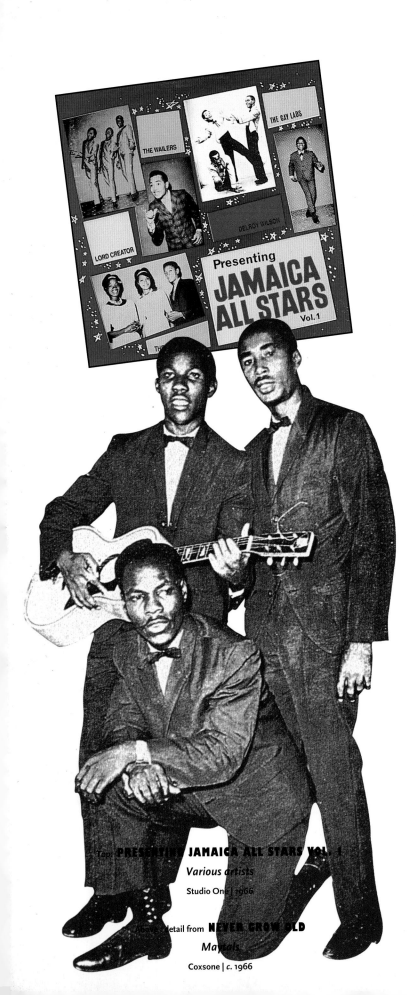

Top: **PRESENTING JAMAICA ALL STARS VOL. 1**

Various artists

Studio One | 1966

Above: detail from **NEVER GROW OLD**

Maytals

Coxsone | c. 1966

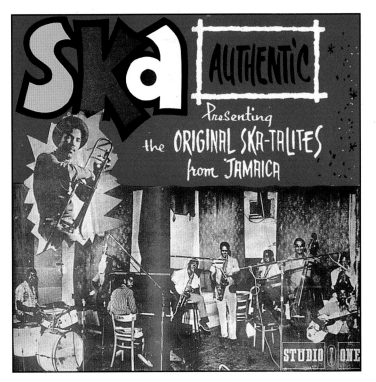

SKA AUTHENTIC

Skatalites

Studio One | 1967

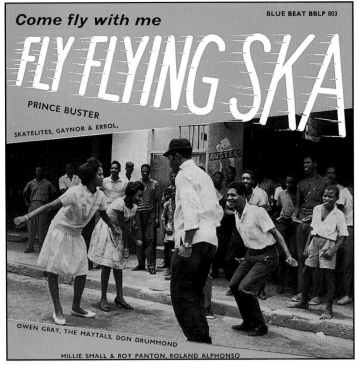

FLY FLYING SKA

Prince Buster

Blue Beat | 1964 | Cover photo: Courtesy of Jamaican Tourist Board

SKA MANIA

Carlos Malcolm and His Afro-Jamaican Rhythms

Upbeat | *c.* 1965 | Cover photo: Courtesy of Jamaican National Dance Co.

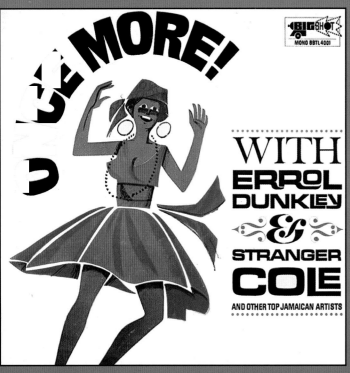

ONCE MORE

Various artists

Big Shot | 1968 | Cover design: CCS Advertising

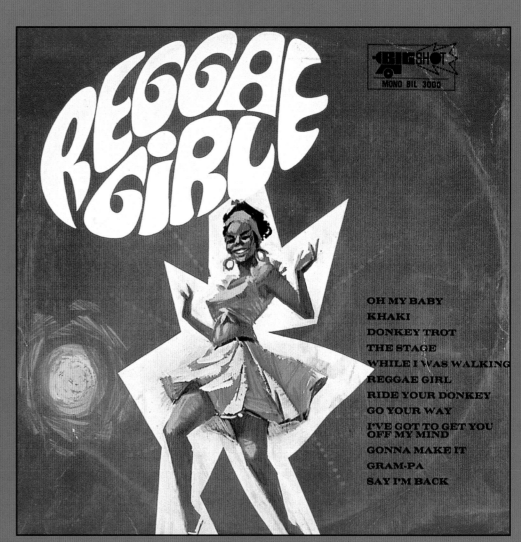

REGGAE GIRL

Various artists

Big Shot | *c.* 1969 | Cover design: CCS Advertising

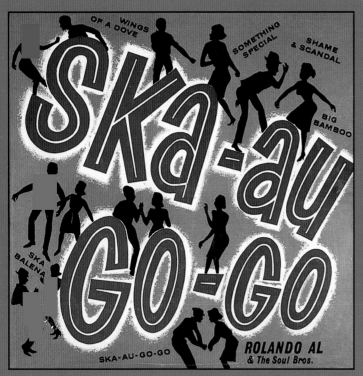

SKA-AU-GO-GO

Various artists

Studio One | 1967

READY STEADY GO

ROCK STEADY

PAMA

PMLP-3. S.P.

VARIOUS ARTISTES

A DIVINE BLACK KING

Portrayed alternately as a conquering warrior, a supernatural being, an African king, and a young innocent, Ethiopian Emperor Haile Selassie was a ubiquitous presence in reggae cover art from the late '60s. The ways in which the Emperor was depicted on countless covers reveal a complex blending of popular and high-art idioms, a potent synthesis that would prove a major force in propagating Rastafarian ideology worldwide.

Ras (Prince) Tafari Mekonnen, born in 1892, became Emperor of Ethiopia in 1930, taking the name Haile Selassie—The Power of the Trinity. His other titles included The Lord of Lords, The King of Kings, and The Conquering Lion of the Tribe of Judah. He was said to be 225th in a line of Ethiopian monarchs whose lineage stretched back to Menelik, the son of the Queen of Sheba and King Solomon. Haile Selassie came to international notice in 1935, when he led the defence of Ethiopia (Abyssinia) against an Italian invasion under Benito Mussolini, and was then forced into exile in England in 1936. In 1941 he returned to Ethiopia, which was finally liberated with the assistance of British forces. He was hailed for retaining Ethiopia's status as the only African state never to fall to a European power during the years of colonialism. Other nations praised him for his attempts to bring Ethiopa into the 20th century, though most of his improvement programs came at the expense of the deprived masses. Yet, despite growing criticism at home, Haile Selassie's popularity hardly waned in Jamaica, especially after his official state visit to the island in 1966. Even after he was deposed in a popular coup in 1974 and after his death the following year, the Rastafarian faith remained firm.

Background: detail from
THE FURTHER YOU LOOK
John Holt
Trojan | 1972 | Cover design: CRP

Opposite top:
MARCUS GARVEY
Burning Spear
Island | 1975 | Cover design: Bloomfield/Travis

Opposite below:
GARVEY'S GHOST
Burning Spear
Island | 1976 | Cover design: Bloomfield/Travis

Opposite: background detail from
KINGS AND QUEENS OF DUB
Roy Cousins
Tamoki/Wambesi | c. 1987

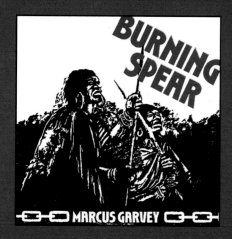

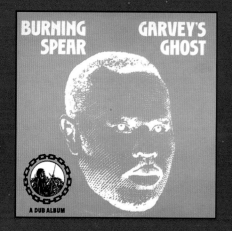

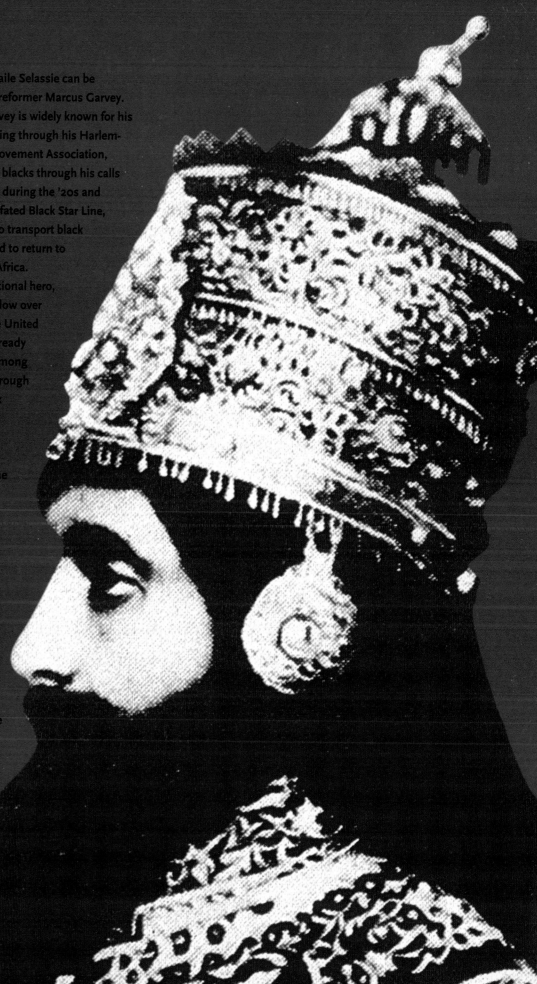

Reggae's connection with Haile Selassie can be traced back to the Jamaican reformer Marcus Garvey. Born in Jamaica in 1887, Garvey is widely known for his activities in America. Operating through his Harlem-based Universal Negro Improvement Association, Garvey galvanized American blacks through his calls for racial solidarity and pride during the '20s and '30s. He also founded the ill-fated Black Star Line, a shipping company set up to transport black North Americans who wished to return to their ancestral homeland of Africa.

In Jamaica, Garvey is a national hero, a figure who still casts a shadow over reggae. Before leaving for the United States in 1916, Garvey had already won a significant following among Jamaica's disenfranchised through his militant advocacy of black pride and Pan-Africanism. To many, it was Garvey who set the stage for Rastafarianism when in his farewell speech he told his Jamaican audience, "Look to Africa, where a divine black King shall be crowned, for the day of deliverance is here." Many took this literally, and in 1930, when the international media carried accounts of Haile Selassie's lavish coronation, it was believed that Garvey's prophesy had come to pass. Ironically, Garvey would later criticise Rastafarianism, offended by the adoration of Haile Selassie that he himself had been so instrumental in creating. For a people long under the yoke of Western imperialism, the crowning of this African king reinforced their belief in African pride and repatriation. By the late '30s, many of Jamaica's poor had come to regard Haile Selassie as a living god, who would deliver Africans from their bondage in the West; Rastafarianism took its name from his princely title Ras Tafari. Two passages in the Bible formed the main justification for this worship. Psalm 68:31, "Princes shall come out of Egypt; Ethiopia shall soon stretch out her hands unto God." Revelation 5:5, "And one of the elders saith unto me, Weep not. Behold, the Lion of the Tribe of Judah, the Root of David, hath prevailed to open the book, and to loose the seven seals thereof."

While the Rastafarians were sincere in their adoration of Haile Selassie, they were also rebelling, as Garvey had rebelled before them, against the Western notion of a white Christian God. Garvey had written, "The God of Isaac and the God of Jacob, let him exist for the race that believe in the God of Isaac and the God of Jacob. We Negroes believe in the God of Ethiopia, the everlasting God—God the son, God the Holy Ghost, the one God of all ages. That is the God in whom we believe, but shall worship him through the spectacles of Ethiopia."

Similar sentiments were being expressed when pictures of Haile Selassie began appearing on the covers of reggae albums. Rastafarianism is a religion without a set doctrine or hierarchy, and therefore traditional forms of proselytizing, such as the dissemination of literature and formal services, have often been unavailable to it. Rather, it was through their depictions of Haile Selassie that Rastafarians were able to announce their departure from traditional Western Christianity and communicate this belief to potential converts.

Haile Selassie is shown on album covers mainly as a powerful deity or as a worldly king. On illustrated sleeves like *African Musium All Star* and *Rockers Almighty Dub*, he assumes supernatural powers, showering the earth with lightning and using his dreadlocks to destroy the structures of Babylon. On the covers where His Imperial Majesty appears as an earthly ruler, he is rarely portrayed with anything less than royal grandeur. Ironically, Haile Selassie's presentation on albums like *Hail H.I.M.* and *Don't Underestimate the Force*, seems more reminiscent of European imperialists like Napoleon or Mussolini (his sworn enemy) than that of a traditional African king. The title of *I Came, I Saw, I Conquered* even suggests a comparison with Julius Caesar. The emergence of Rastafarianism would raise considerable debate on the question of whether Haile Selassie could be more than a mortal man. But for those of African descent, the greatest impact of reggae cover art ultimately lay in putting an African face on the type of power and holiness that had historically been reserved for Europeans.

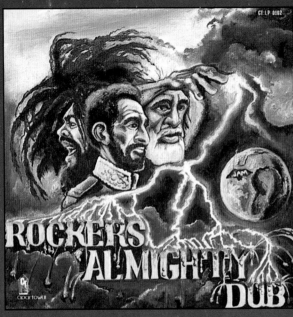

ROCKERS ALMIGHTY DUB

Bunny Lee Productions

Clocktower | *c.* 1978 | Cover illustration: Jamaal Pete

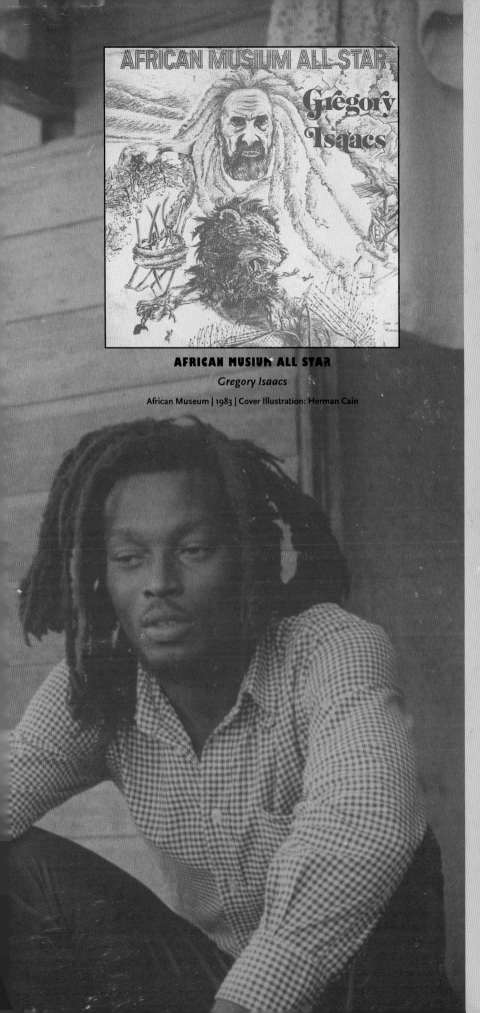

AFRICAN MUSIUM ALL STAR

Gregory Isaacs

African Museum | 1983 | Cover Illustration: Herman Cain

Pictures of Haile Selassie might have been reggae's most orthodox expression of Rastafarian faith, but the religion was spread through album covers in other ways as well. Marcus Garvey's teachings and influence on the early Rastafarian movement were saluted on many reggae sleeves. And many reflected the fact that Rastafarians, deeply familiar with the Bible, associated the plight of Jamaicans with that of the ancient Israelites enslaved in Babylon, yearning for Zion, the promised land. This was apparent in covers that made reference to Babylon and to Zion (for Rastafarians, Africa was the promised land, and a few did manage to emigrate to the Shashamane region of Ethiopia). Lions were also commonly used to suggest Rastafarian power—the lion was Ethiopia's symbol and one of the Emperor's titles. But apart from sleeves featuring Haile Selassie, the image that would become most associated with the religion, and indeed reggae in general, would be that of the dreadlocked Rastafarian.

Dreadlocks, the long, uncombed locks of hair that many Rastafarians wear as a sign of their faith, were the centerpiece of a multitude of covers, particularly during the '70s. It has been suggested that the wearing of dreadlocks could have been inspired by the lion's mane, the warriors of East African tribes, or Biblical verses such as Numbers 6:5, "Until the days be fulfilled ... he shall be holy, and shall let the locks of his head grow." Dreadlocks captured the rebelliousness and vitality of Rastafarianism, with the dreadlocked artist providing a stamp of authenticity. Of course, not all dreadlocked artists were Rastafarians, and not all Rastafarians wore dreadlocks, but this didn't detract from the interest these covers generated. Audiences were captivated by the defiant style, worn proudly with complete disregard for convention. In time the term "dread" would signify not only dreadlocks, but the heavy, commanding vibe associated with Rastafarianism. A classic "dread" cover is The Congos' *Heart of The Congos*. This album was produced by Lee Perry, who initially only released several hundred copies of the LP on his own Black Art label owing to a dispute between Perry and Island, his normal distributor. The album's front cover shows The Congos participating in a favourite Rastafarian pastime, Nyahbinghi drumming, a means by which Rastas could stay connected culturally and musically with their African roots. The original edition's sleeve also boasts handpainted stripes by an unknown painter at Perry's Black Ark studio. Although in time dreadlocks would become as much a fashion statement as a symbol of faith, they remain inexorably linked with Rastafarianism and reggae.

What is truly remarkable about all these sleeves is that they were able to make religious devotion hip. During the '70s, while the rest of the music world was inevitably creeping towards the excess and materialism that would plague disco and the '80s, reggae was spearheading a powerful religious movement. If the mystical spirituality preached by hippies and the counterculture had become blasé and ineffectual, Rastafarianism countered with a commanding presence. Jackets like *Rastafari* or *Black Star Liner* suggest a movement that was at once solemn yet powerful, spiritual yet visceral. While most overtly religious jackets would have been scoffed at by mainstream music audiences, Rasta-related covers were met with fascination and respect. Graphically these covers might have lacked the complexity of rock or jazz covers, but they exuded such confidence that their message was quickly absorbed by fans throughout the world. Attempting to blend religion and history with pop sensibilities is a difficult maneuver, but these sleeves succeeded through the power and appeal of Rastafarianism's conviction.

RASTAFARI

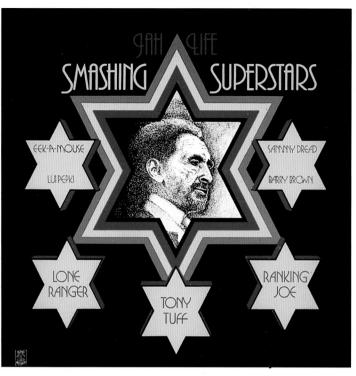

SMASHING SUPERSTARS

Various artists

Vista Sounds | 1983 | Cover design: O'Neil Nanco

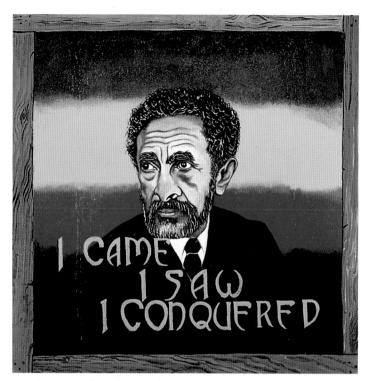

I CAME, I SAW, I CONQUERED

Revolutionaries

Channel One | 1981 | Cover illustration: Jamaal Pete

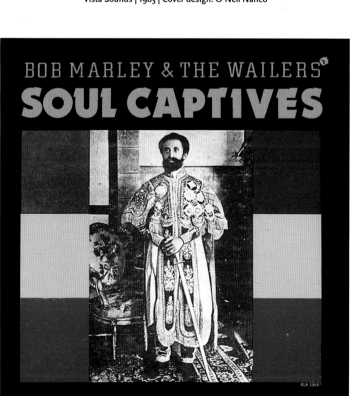

SOUL CAPTIVES

Bob Marley and The Wailers

ALA | 1986 | Cover design: Rhonda Voo

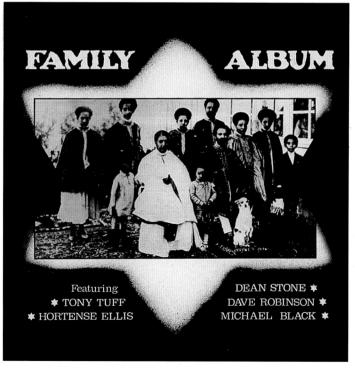

FAMILY ALBUM

Various artists

Live and Learn | *c.* 1984 | Cover design: O'Neil Nanco

RASTAFARI

Ras Michael & The Sons Of Negus

Vulcan | 1975 | Cover design: Neville Garrick

The Seed of Solomon

The Queen of Sheba, The Queen of the South, ruled a country on the Red Sea in part of what is now Arabia.

She was determined to see the magnificence of Solomon's kingdom and she journeyed from her own country to his royal court bearing gifts and armed by her own famous beauty, for she was then considered one of the most beautiful women in the world.

She was not disappointed. All that she heard of the glory of Solomon's court was true. The Queen of Sheba remained at Solomon's side asking for his advice so that she could return to her own country and govern with equal wisdom and splendour. However, for a time she did become the companion of great King Solomon and she bore him a son. According to the Kebra Negast, this was Solomon's first-born son. He was named "Ibn Hakim" and his father gave him a jewelled ring, by means of which he could prove to the world his descent from the ruler of the land of the Jews.

According to the Kebra Negast, "his whole body and its members and the bearing of his shoulders resembled those of King Solomon his father" and so was established the line of Kings who rule Ethiopia today, for the people of the Queen of Sheba crossed the Red Sea from Arabia and established themselves in the high mountains beyond the plains on the western coast.

And so it is from Solomon, King of the Jews, that his imperial Majesty–Haile Selassie I, King of the Kings of Ethiopia, Conquering Lion of the tribe of Judah is descended. Between Solomon and Haile Selassie stands a line of 323 Kings, giving Ethiopia the oldest monarchy in the world.

Above and below right: details from back cover of

NYAHBINGHI

Ras Michael & The Sons of Negus

Trojan | 1974 | Jacket concept: Tommy Cowan

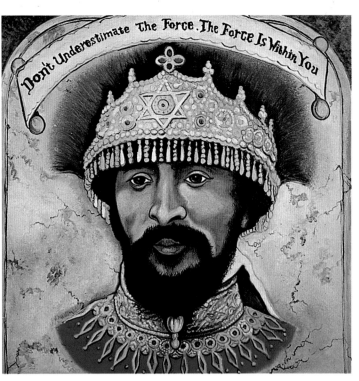

DON'T UNDERESTIMATE THE FORCE

Revolutionaries

Channel One | 1981 | Cover Illustration: Jamaal Pete

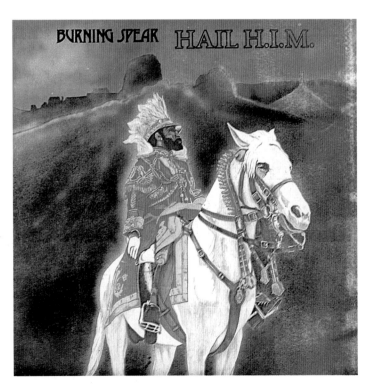

HAIL H.I.M.

Burning Spear

EMI | 1980 | Cover illustration: Neville Garrick

The Birth of Haile Selassie

It was at Ejarsa Gorsa, in Ras Makonnen's summer house, built of mud and wattle, with a broad, cool verandah, that Haile Selassie was born.

While his mother waited, outside the big house the women prayed and loo-looed in their curious manner, a soft, humming, musical sound. Almost at the instant of the boy's birth, the hillsides shuddered under heavy thunder. The sound rolled away like artillery in the distance and then the dark skies burst and the rain came down in torrents. In a country where rain is always needed, the storm was taken as a sign that the newborn infant was especially blessed. The women loo-looed and offered thanks to God. The baby's lips were moistened with ritual butter. In the village of Ejarsa Gorsa, hill tribesmen fired their rifles in celebration.

For two nights the people celebrated cutting towards themselves with sharp knives. They drank their fill of Tej and Talla, the national drinks of Ethiopia.

On the morning of November 2, 1930, as dawn broke over the eastern highlands and dew was fresh on the brilliant grass, the Archbishop Kyril anointed with holy oils the head of the new Emperor and upon it he placed the triple crown of the Ethiopian monarch. The Rases put on their coronets. They bowed to the new King of Kings, Negus Negusti. Then all over the city there burst into the morning air the roars and cheers of the people as the Emperor and his Empress marched beneath a series of triumphal arches. Army officers in full dress moved among the foreign guests, offering coronation medallions as souvenirs of the great occasion.

KING TUBBYS MEETS ROCKERS UPTOWN

King Tubby/Augustus Pablo

Clocktower | 1976 | Cover design: Glen Osborne

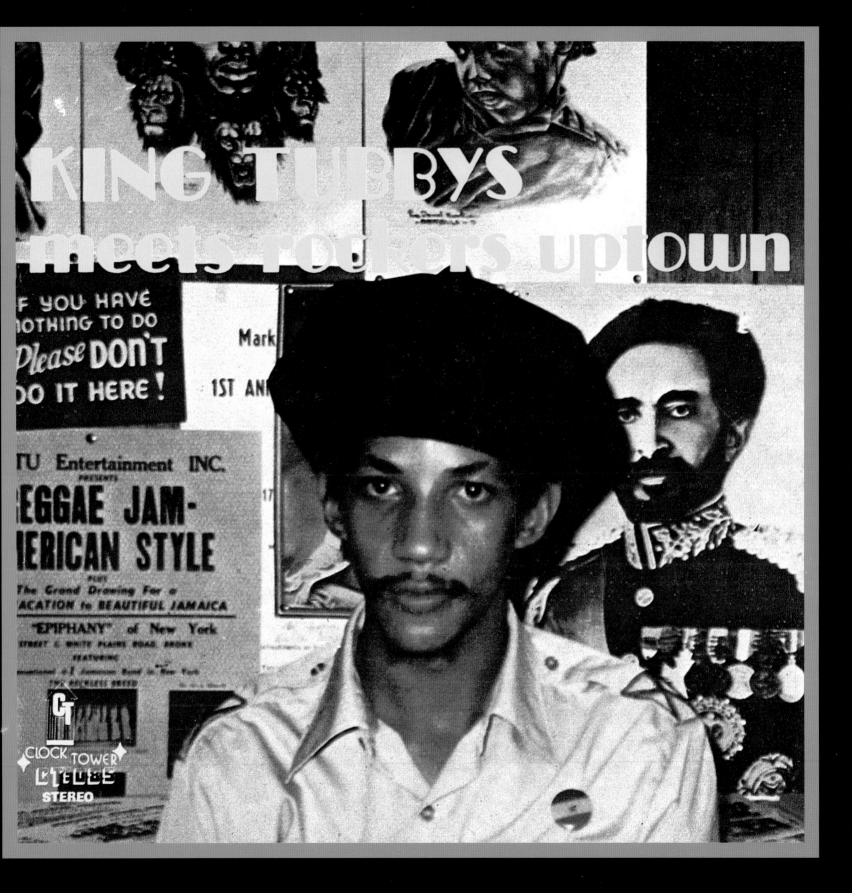

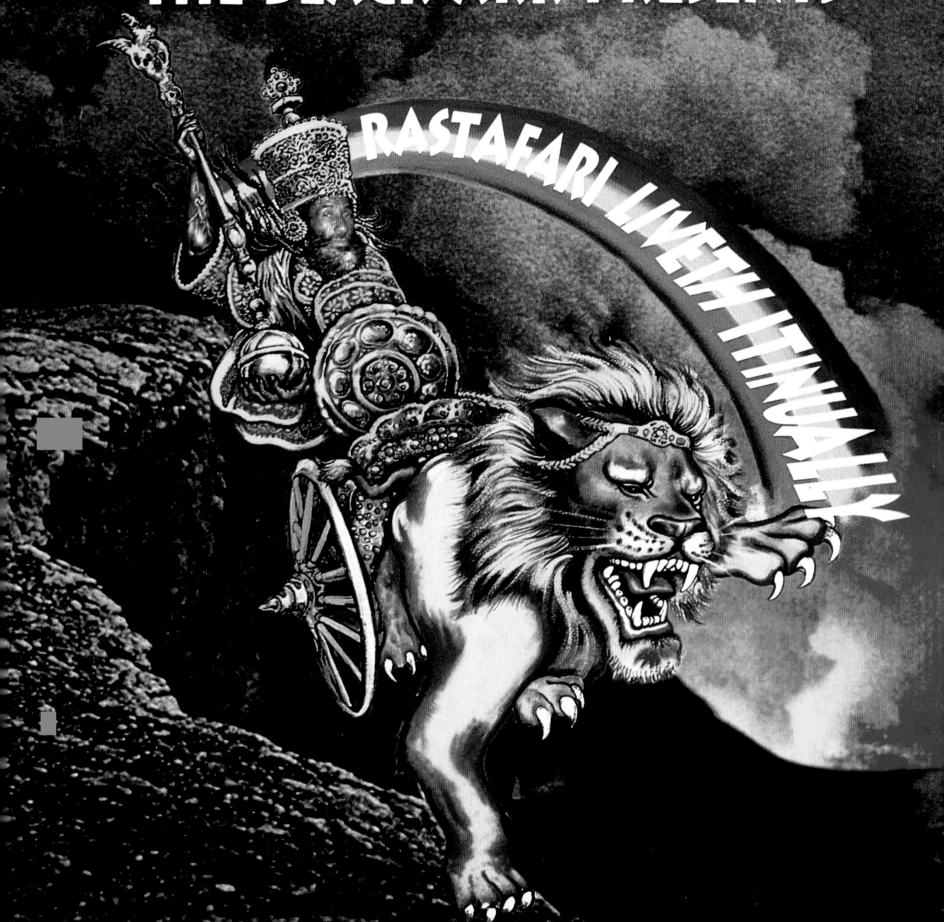

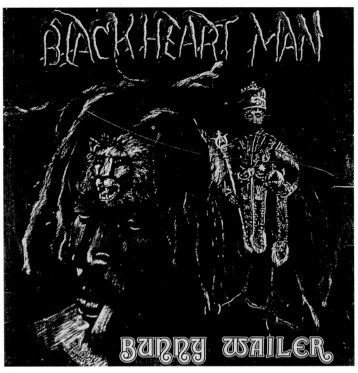

BLACKHEART MAN

Bunny Wailer

Solomonic | 1976 | Cover design: Neville Garrick and Bunny Wailer

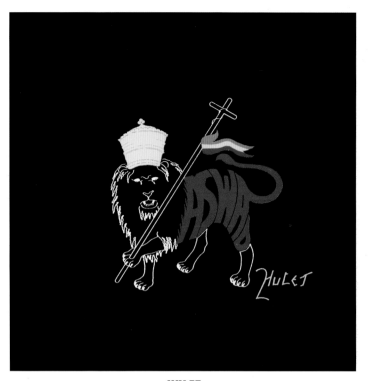

HULET

Aswad

Grove Music | 1978

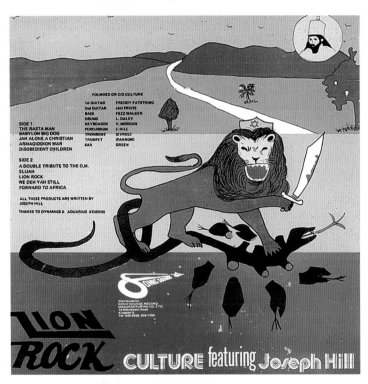

LION ROCK

Culture

Sonic Sounds | 1981| Back cover illustration: Wilfred Limonious

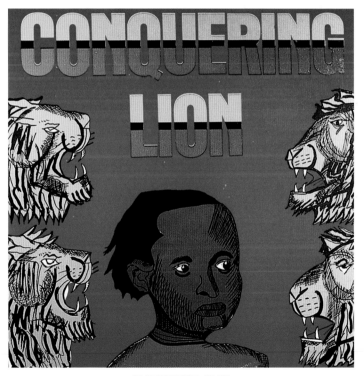

CONQUERING LION

Yabby-You and The Prophets

Micron | 1976 | Cover illustration: Cogil Leghorn

RASTAFARI LIVETH ITINUALLY

Lee Perry

Justice League | reissue | 1998

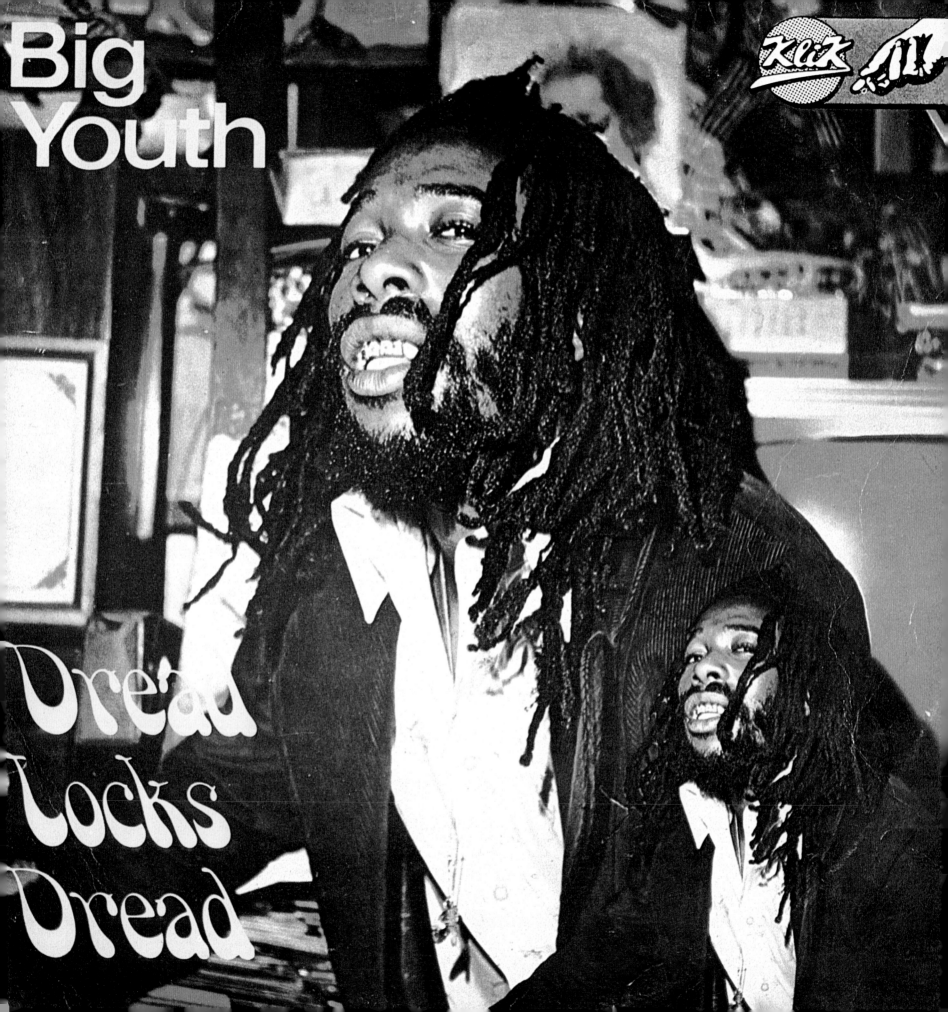

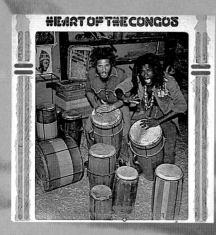

HEART OF THE CONGOS
The Congos

Black Art | 1977 | Cover design: Gillian A. Gordon

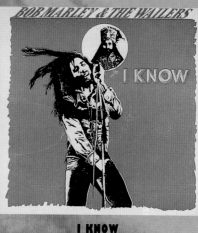

I KNOW
Bob Marley and The Wailers

Tuff Gong | 7" | 1981 | Cover design: Neville Garrick

CONGO
The Congos

CBS | 1979
Cover photo:
Antoine Giacomoni

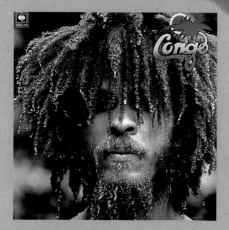

Left, and below (inside sleeve) :
BLACK STAR LINER
Fred Locks

Vulcan | 1976 | Cover design: Fred Locks,
Booty & Jahmik

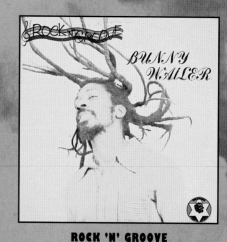

ROCK 'N' GROOVE
Bunny Wailer

Solomonic | 1981 | Cover design: Bunny Wailer

DREAD LOCKS DREAD
Big Youth

Klik | 1975

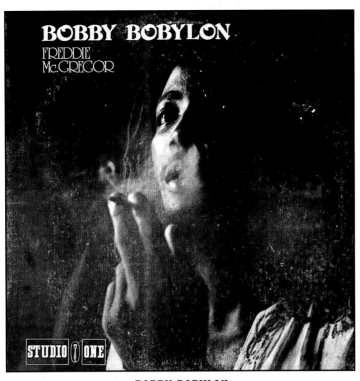

BOBBY BOBYLON

Freddie McGregor

Studio One | 1980 | Cover design: Glenville Dayle

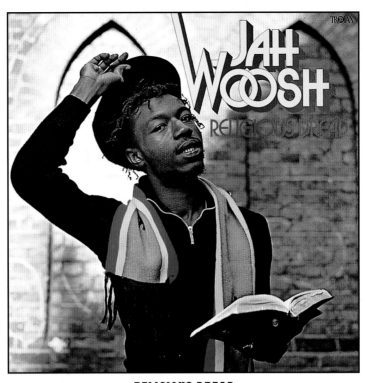

RELIGIOUS DREAD

Jah Woosh

Trojan | 1978 | Cover design: Chess Creative Services

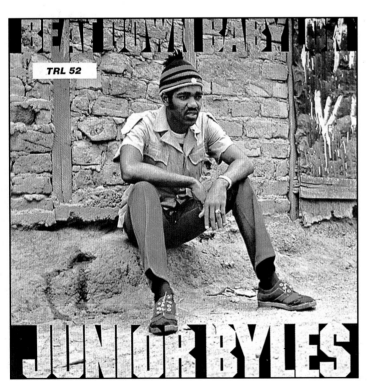

BEAT DOWN BABYLON

Junior Byles

Trojan | 1973 | Cover design and Photo: Howard Moo Young

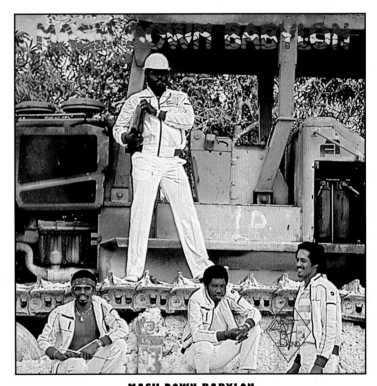

MASH DOWN BABYLON

The Memory of Justice Band

Platinum Express | 1983

JERUSALEM

Alpha Blondy

Shanachie | 1986 | Cover design: Georges Kouakou | Cover illustration: Ekike G.

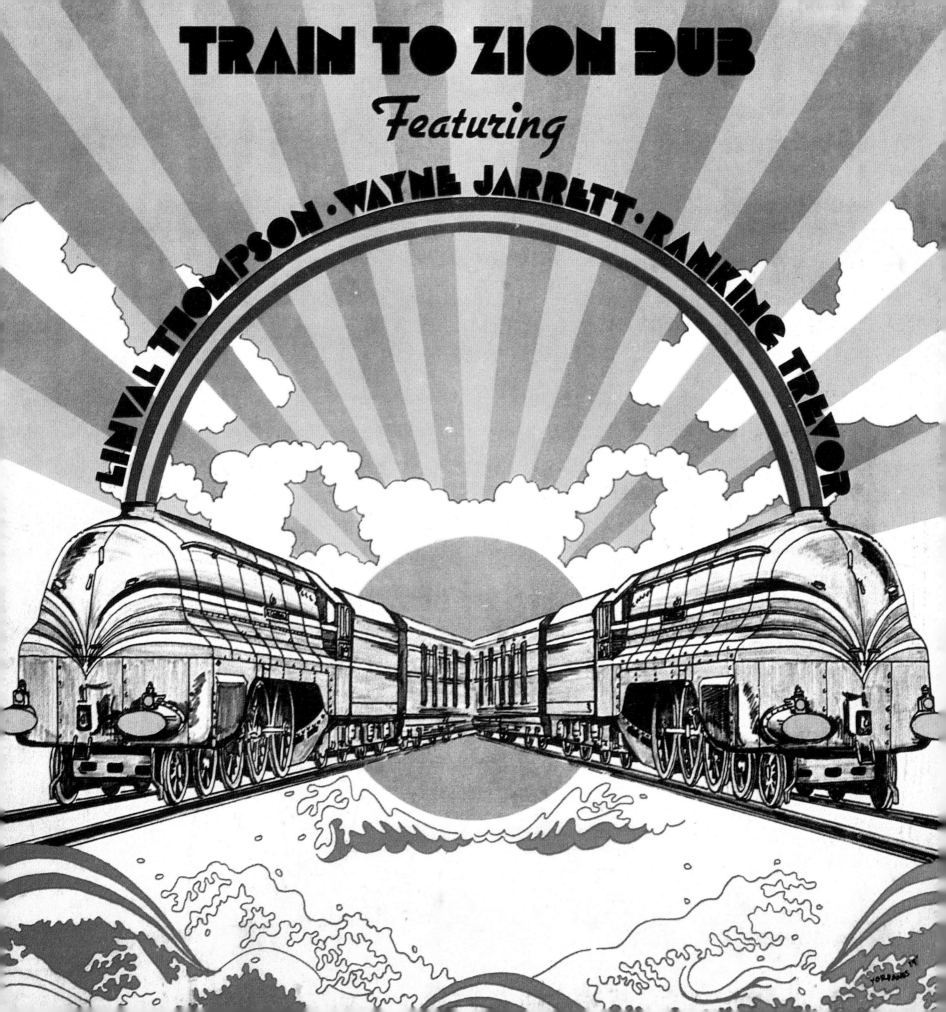

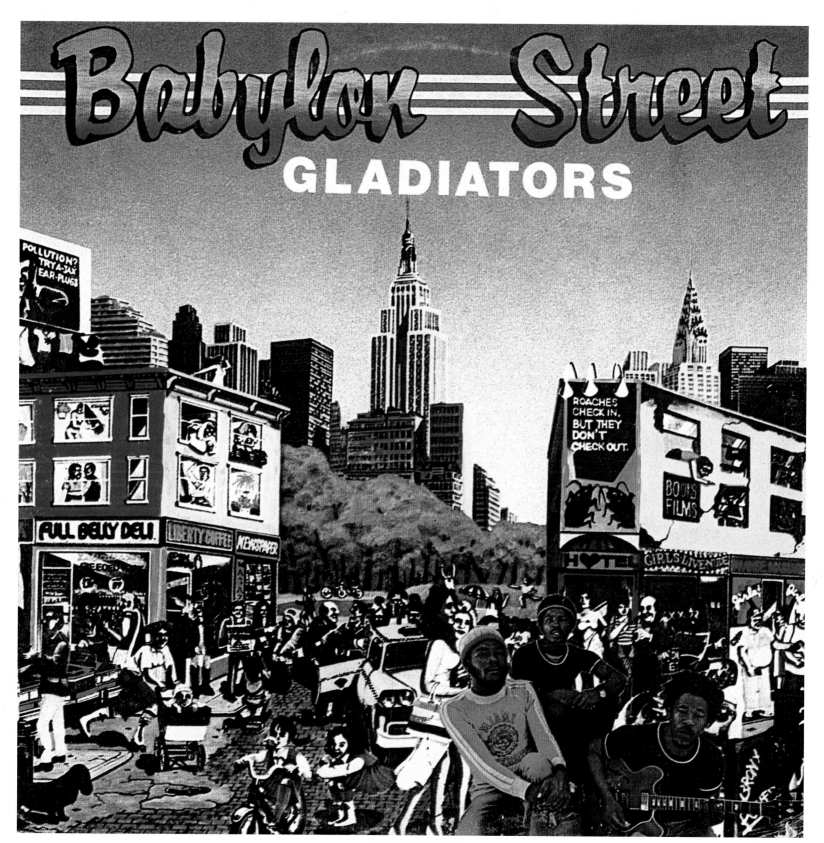

BABYLON STREET

Gladiators

Jam Rock | *c.* 1977

TRAIN TO ZION DUB

Various artists

Tuff Gong | 1981 | Cover design: Neville Garrick

LAND OF AFRICA

"AFRICA MUST BE FREE BY 1983," demanded the cover of Hugh Mundell's 1978 album of the same name. Reggae fully embraced its African heritage during the '70s, and the continent of Africa became a favorite symbol of reggae designers. Africa's influence had always been present in reggae's music and lyrics, but its early fascination with R & B resulted in album covers that were more likely to pay tribute to Motown than Mozambique.

By the '70s, artists were eager to bring Pan-Africanism to reggae's expanding audiences, transforming the continent from a distant legend into a vibrant reality. As designer Neville Garrick notes, "At that time [the mid-1970s] our audience who were buying the records were really young white college kids, and I wanted to reveal the message in there. So in every way I could I make it [the cover] afrocentric or makes images of Africa, I would do it, to try to make some common ground ..."

Many reggae covers had African themes. The Revolutionaries' *Jonkanoo Dub* acknowledges the roots of the John Canoe festival, an annual Jamaican event in which masked musicians serenade revelers, a direct descendant of West African harvest rituals. The Pioneers' *Roll on Muddy River* shows life along the great River Niger. The victory of Ethiopian Emperor Menelik over Italian forces at Adowa in 1896 is illustrated in traditional Ethiopian style on the inside sleeve of Bob Marley's *Confrontation*.

Although most Jamaicans can trace their ancestry to Central and West Africa, reggae cover art tends to treat Africa not as a group of nations but as an entity. As with *Africa Must Be Free By 1983*, the continent is often shown in outline, without national boundaries and as a commanding unified presence. Mutabaruka's *Outcry* calls for Afro-Arab unity by subtly slipping the Sinai and Saudi Arabia into Africa's boundaries, while the 1984 compilation *Land of Africa*, released to raise money for Ethiopian famine victims, transforms Africa's outline into a weeping face.

Perhaps the most ambitious cover to address reggae's relationship with Africa is Bob Marley's *Survival*. Its designer Neville Garrick recalls: "The original title of the album was *Black Survival*. And I said to Bob that *Black Survival* might alienate some people and stuff like that. So I'm going to try to find a way to graphically say black without using the word. Well, OK, if I'm showing the survival of the black race then Africa should definitely be the theme of it. I decided to use all the independent country flags in Africa. Then I had a little problem with Zimbabwe. Wasn't really fully a nation yet and it was being represented by two patriotic fronts. So if you look at *Survival*, you'll notice that I had ZANU and ZAPU, which was the acronyms for the two revolutionary parties fighting against the government. Since I didn't know which was going to win, Zimbabwe had two flags. And there was no South African flag, only free African nations. And then I had the problem of how do I represent the blacks outside of Africa? Do I put Jamaica's flag? Jamaica has all kinds of people there. Do I put Trinidad's flag? No, that's too many flags, all the Caribbean. Then the idea came, well most of the African people came through slavery. So I used the plan of the slave ship and reversed out the type 'Survival' on it. So that would represent the blacks that were outside of Africa. The Diaspora."

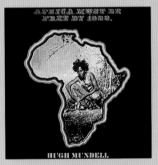

AFRICA MUST BE FREE BY 1983

Hugh Mundell

Message | 1978

Cover Photography: D. Ellis Design

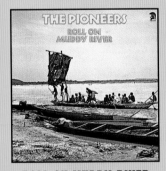

ROLL ON MUDDY RIVER

The Pioneers

Trojan | 1977

Background: detail from

LAND OF AFRICA

Various artists

Ras | 1984

Cover illustration: Neville Garrick

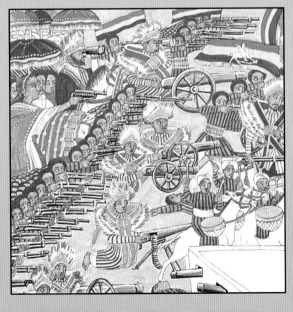

Detail from inside sleeve

CONFRONTATION

Bob Marley and The Wailers

Island | 1983 | Illustration: Neville Garrick

JONKANOO DUB

The Revolutionaries

Hit Bound | 1978 | Cover design: Len Roberts

JONKANOO DUB
THE REVOLUTIONAIRES

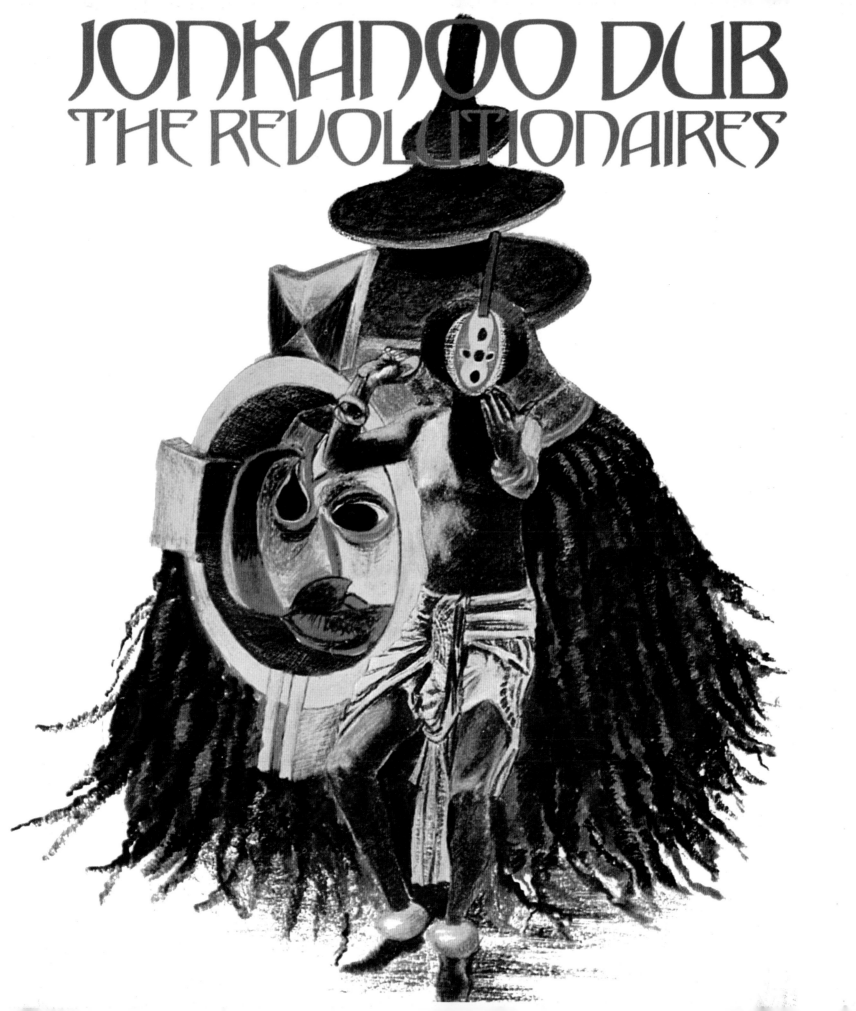

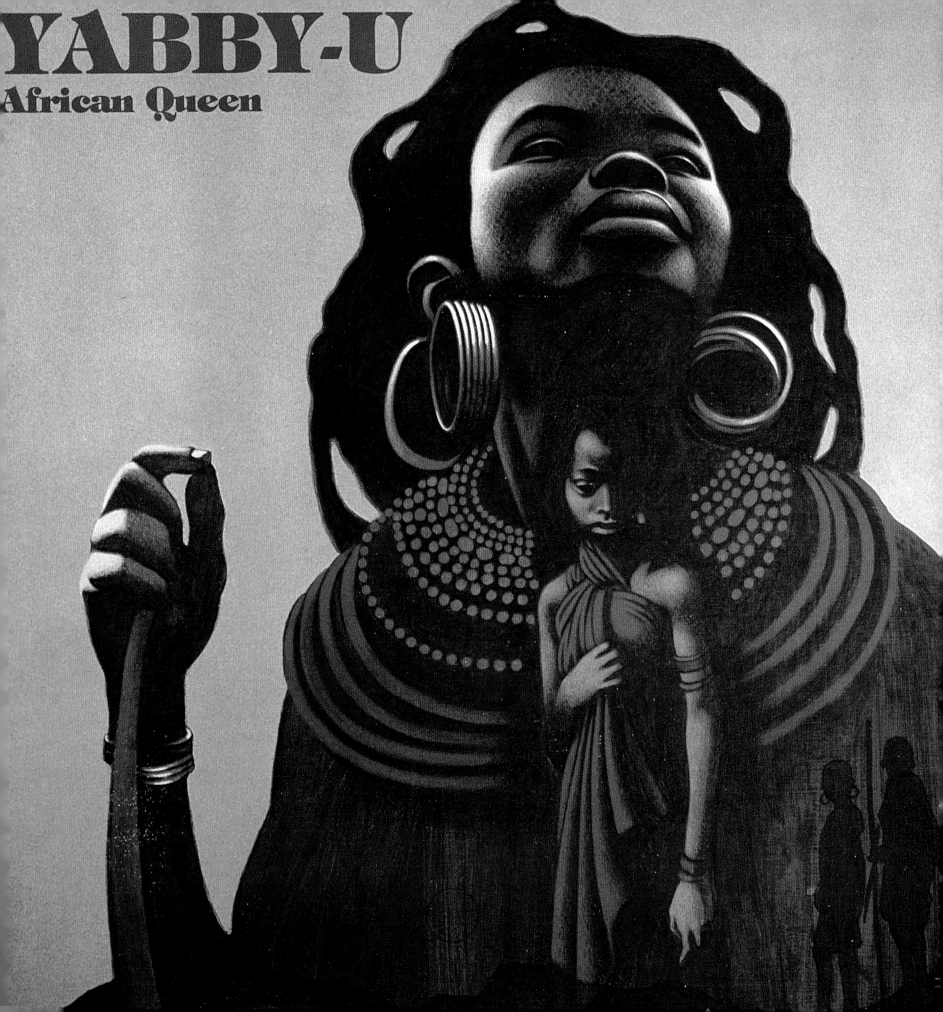

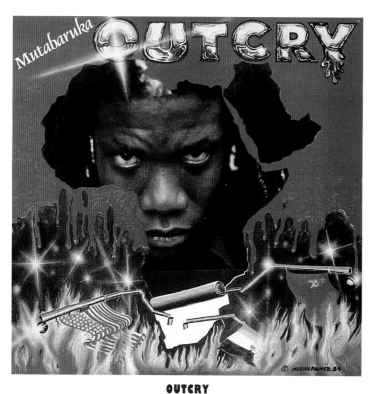

OUTCRY

Mutabaruka

Shanachie | 1984 | Cover design: Mervin Palmer

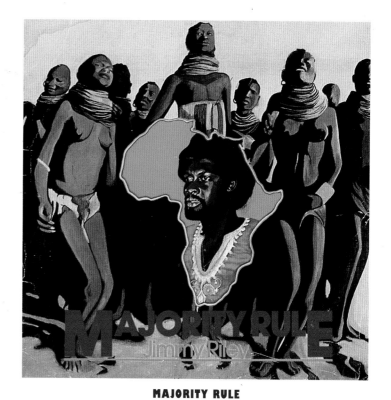

MAJORITY RULE

Jimmy Riley

Burning Sound | 1978 | Cover illustration: Earl Neish

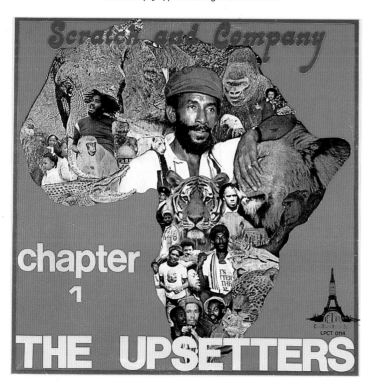

SCRATCH AND COMPANY CHAPTER 1

The Upsetters

Clocktower | c. 1979 | Cover design: LAM Graphics

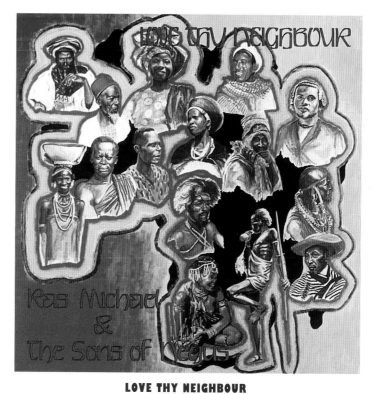

LOVE THY NEIGHBOUR

Ras Michael & The Sons Of Negus

Live and Learn | 1984 | Cover design: O'Neil Nanco

AFRICAN QUEEN

Yabby-U

Clappers | 1982 | Cover design: T. Smith

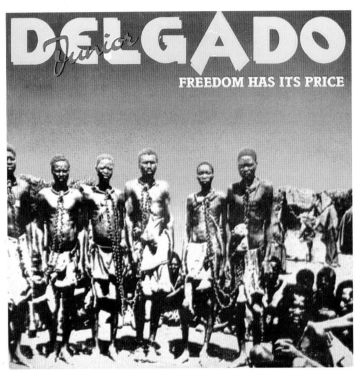

FREEDOM HAS ITS PRICE

Junior Delgado

Incredible Music | *c.* 1984 | Cover design: J. Paco Dennis

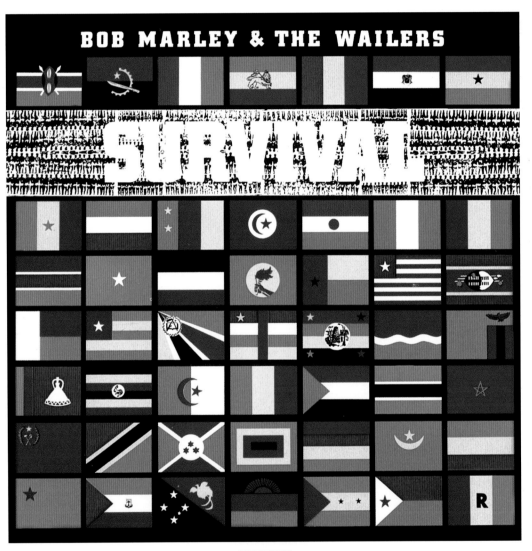

SURVIVAL

Bob Marley & The Wailers

Island | 1979 | Cover design: Neville Garrick

TALES OF MOZAMBIQUE

Count Ossie and the Mystic Revelation of Rastafari

Dynamic | 1975

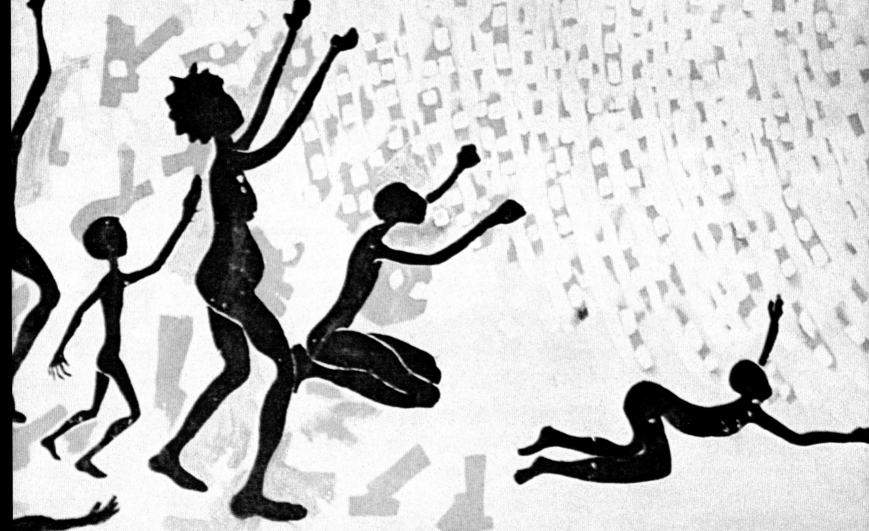

COUNT OSSIE
MYSTIC REVELATION
of
RASTAFARI

TALES of MoZAMBiQUE

PROTEST

One of reggae's most admirable attributes is its tenacity in addressing political issues. Functioning as an underground newspaper, reggae is known among Jamaicans as the "talking *Gleaner*," after Jamaica's oldest daily. For many Jamaicans, both at home and abroad, reggae's album covers were a source of information on issues overlooked by the mainstream press.

Reggae's rise in popularity coincided with a particularly tumultuous period in Jamaican politics, as rival political parties vied for control of the island after it gained independence from England in 1962. In 1970, reggae was thrust into the political arena when the PNP (People's National Party) selected two reggae tunes as official campaign songs, seeking to tap into reggae's grass-roots popularity. Delroy Wilson's "Better Must Come" and Max Romeo's "Let The Power Fall" became rallying cries during the PNP's successful bid to overthrow the JLP (Jamaican Labour Party) in the 1970 general election. Ironically, Wilson never intended a political meaning for "Better Must Come." The lifestyle portrayed on the album's cover was supposed to announce the resurrection of his slumping singing career, not what was in store for Jamaicans after a PNP victory.

Most reggae covers were more deliberate in their messages on such problems as Jamaica's perpetual poverty or Kingston's controversial gun courts. Covers like Sammy Dread's *Road Block* and Yellowman's *Operation Radication* used humor in their attacks on increased police harassment. In typical reggae fashion, *Operation Radication* parodies the JLP's Operation Squads, known as Radication Squads because of their reputation for making political opponents disappear—murderous troops become tiny Yellowmans who parachute into neighborhoods and kick down doors. As the PNP's socialist platform gained popularity in the mid-'70s, reggae covers reflected the people's revolutionary sympathies. Sleeves such as The Revolutionaries' *Revolutionaries Sounds* and The Mighty Diamonds' *Stand Up to Your Judgment* testified to reggae's support of the radical movements unfolding throughout the Third World.

Similarly, sleeves for British reggae bands reflected unrest in the UK in the early '80s. As Britain suffered a severe economic depression, Brixton, London's largest black neighborhood, was the scene of violent clashes in 1981 between police and residents. These tensions are foreshadowed on the cover of Linton Kwesi Johnson's *Dread, Beat An' Blood* and memorialized on Virgin's compilation *The Front Line* (a local nickname for Brixton).

Remarkably, as both Jamaica and Britain suffered through economic hardships, reggae artists were able to look beyond local tribulations and speak to the one issue that transcended all others: nuclear war. Some of reggae cover art's most important statements were made in its unflinching warnings against the arms race and those who led it. Covers like Peter Tosh's *No Nuclear War* and Michael Prophet's *Righteous Are The Conqueror* graphically articulate reggae's opposition to the arms race and offer dire warnings against the superpowers' courtship with Armageddon.

Background:

detail from **PROTEST**

Bunny Wailer

Mango | 1977

BETTER MUST COME

Delroy Wilson

Dynamic | 1972

Cover design: Roberts Design Group

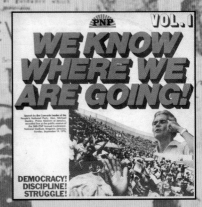

WE KNOW WHERE WE ARE GOING

Various artists

PNP | *c.* 1976

Cover design: Moo Young

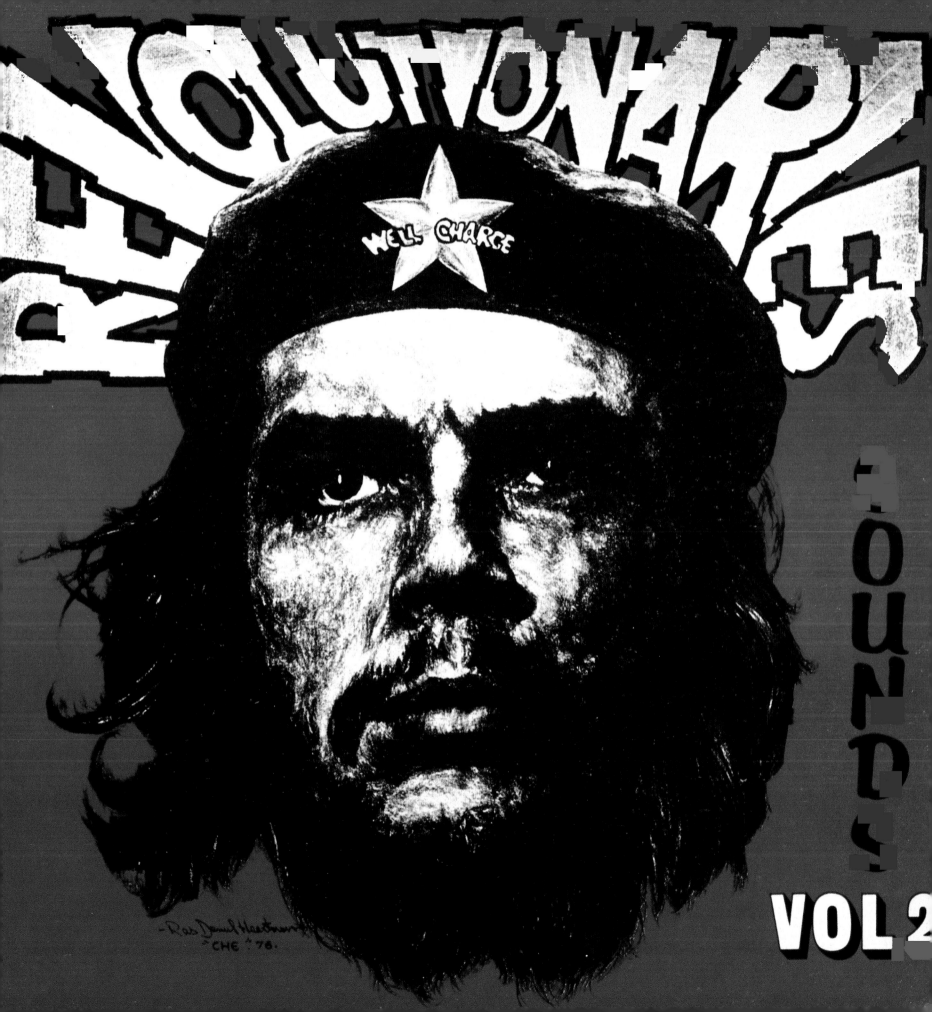

Background: detail from

**YOUTHMAN
PENITENTIARY**

Edi Fitzroy

Alligator | 1982

Cover design: Bob McCamant

Cover photo: Peter Simon

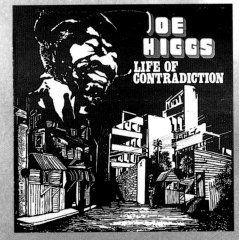

LIFE OF CONTRADICTION

Joe Higgs

Grounation | 1975 | Cover design: Trevor Campbell

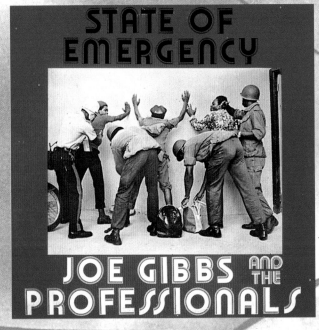

STATE OF EMERGENCY

Joe Gibbs and The Professionals

Rocky One | *c.* 1983

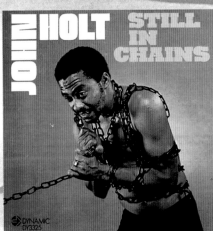

STILL IN CHAINS

John Holt

Dynamic | 1973 | Cover design: Roberts Design Group

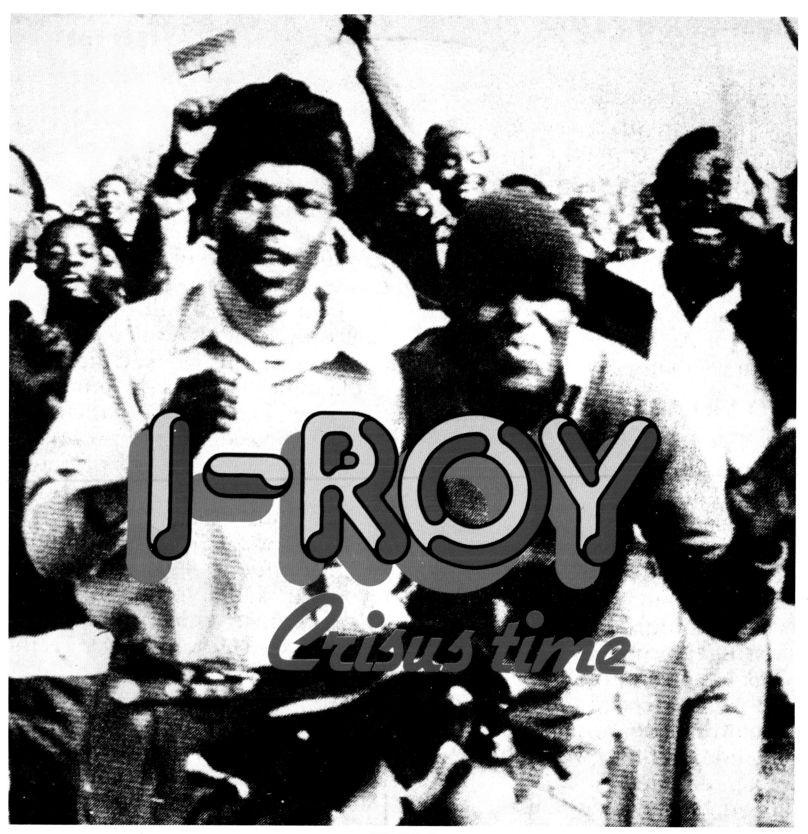

CRISUS TIME

I-Roy

Virgin | 1976 | Cover design: Cream

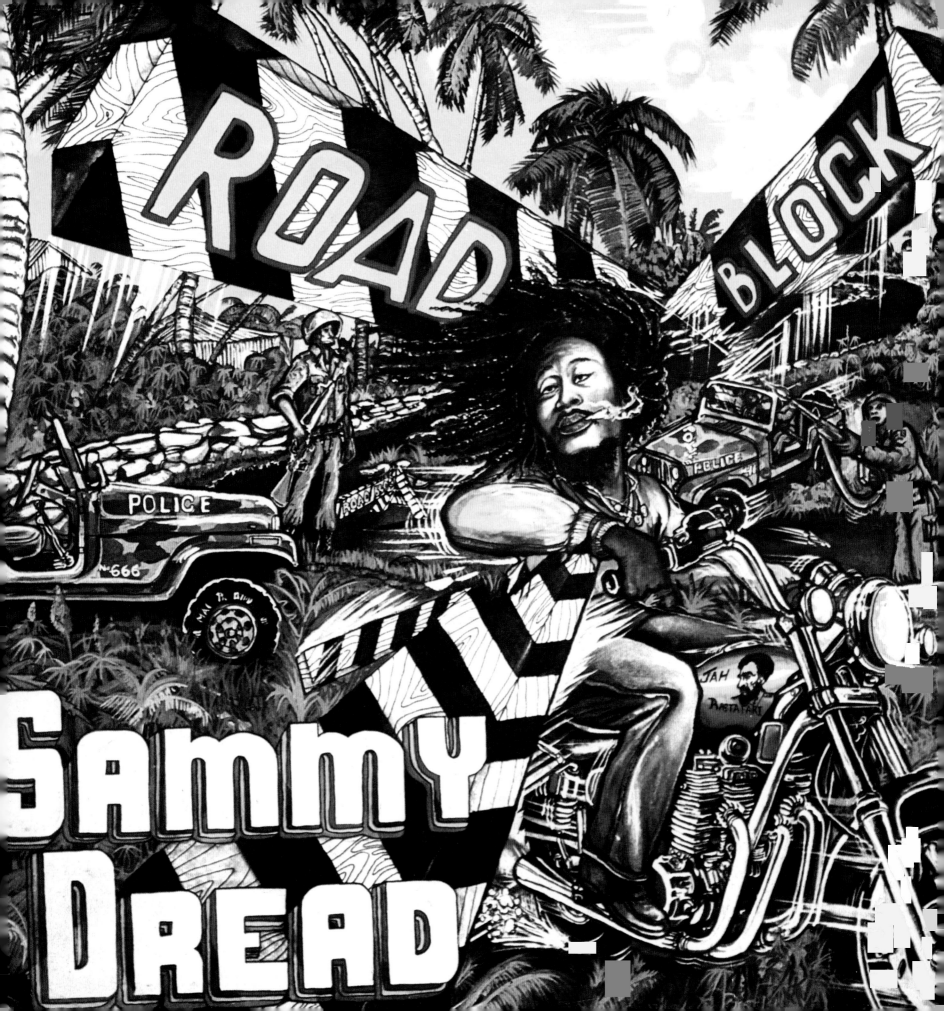

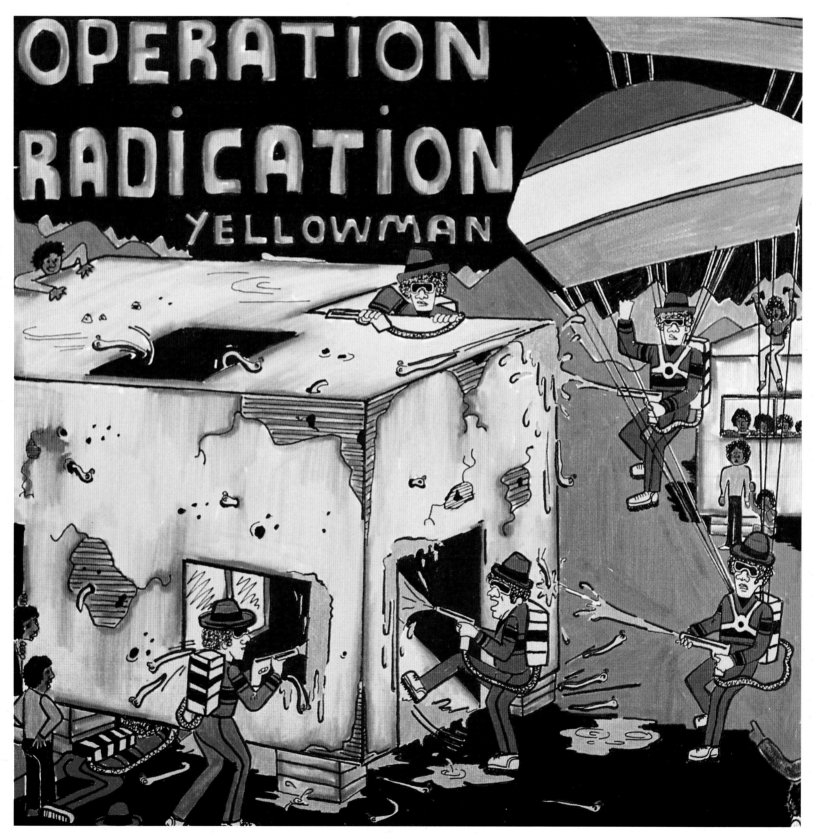

OPERATION RADICATION

Yellowman

Pama | 10" LP | 1982 | Cover illustration: Robert Walters

ROAD BLOCK

Sammy Dread

Channel One | 1982 | Cover illustration: Jamaal Pete

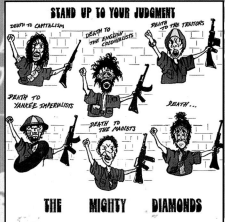

STAND UP TO YOUR JUDGMENT

The Mighty Diamonds

Channel One | 1978

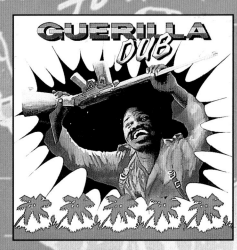

GUERRILLA DUB

The Aggrovators & The Revolutionaries

Burning Sounds | 1980 | Cover design: Ross | Waters

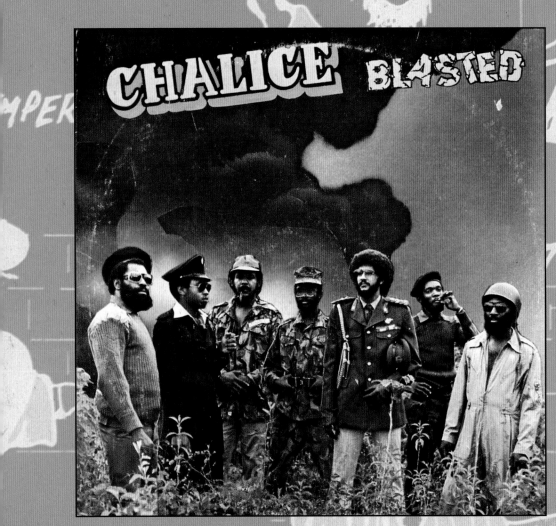

AGROVATORS MEETS THE REVOLUTIONERS

The Aggrovators & The Revolutionaries

Third World | 1977

BLASTED

Chalice

Pipe Music | 1981 | Cover design: W. Armond & Webster Walker

LINTON KWESI JOHNSON

DREAD BEAT AN' BLOOD

DREAD, BEAT AN' BLOOD

Linton Kwesi Johnson

Heartbeat | 1978 | Cover design: Susan Marsh

THE FRONT LINE

Various artists

Virgin | 1976 | Cover design: John Varnom

The Front Line

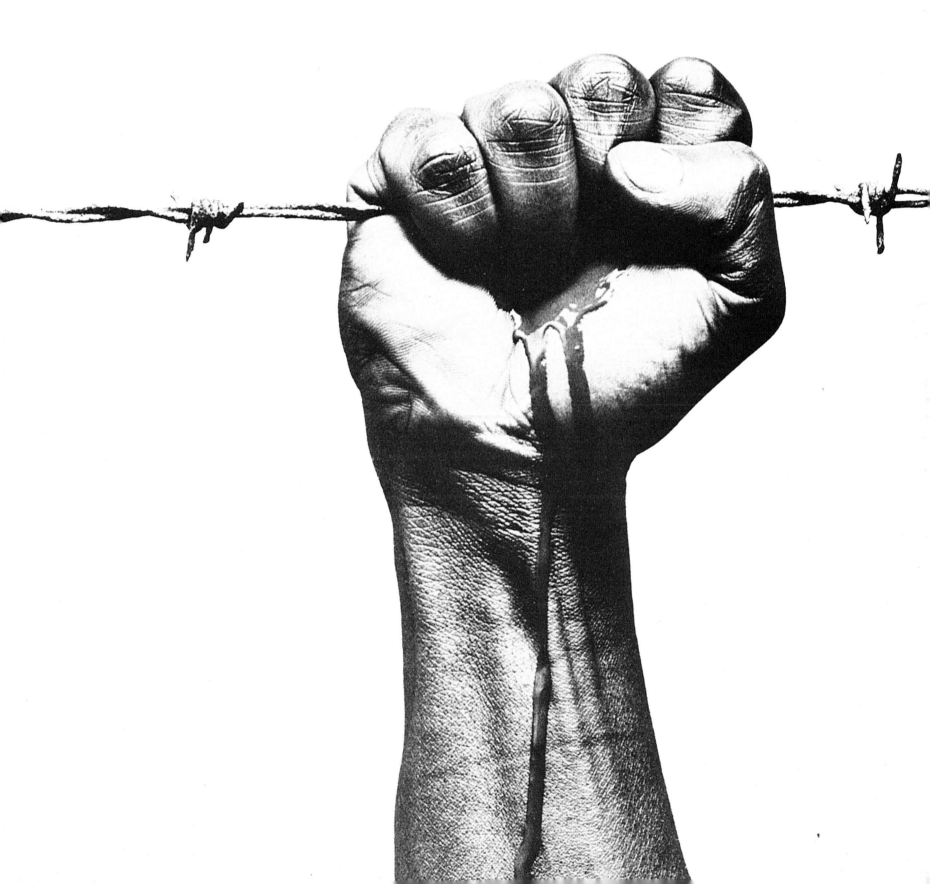

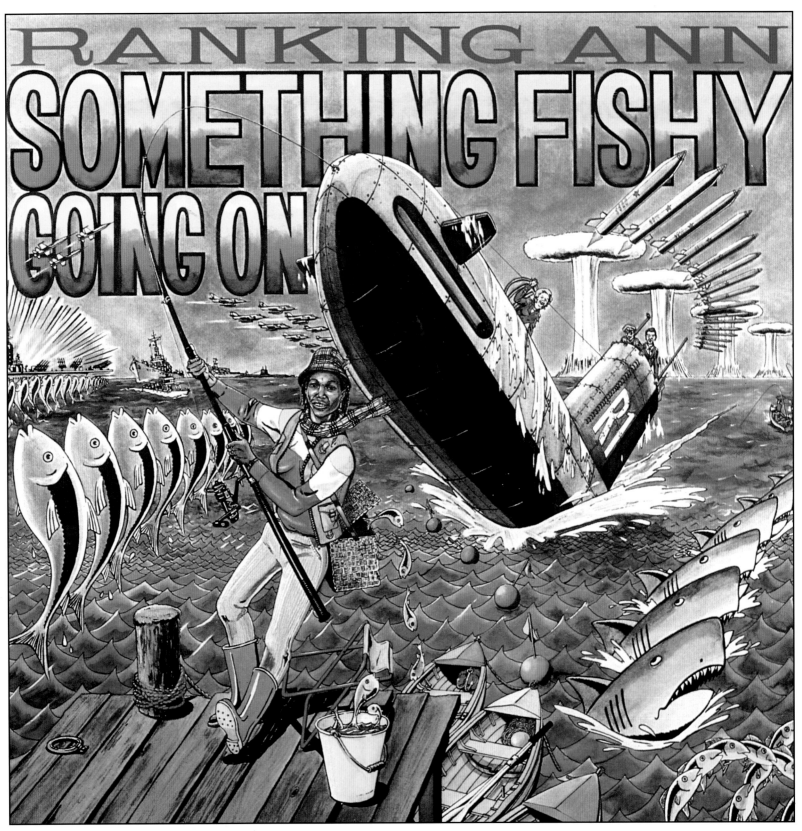

SOMETHING FISHY GOING ON

Ranking Ann

Ariwa | 1984 | Cover illustration: Tony & Michael McDermott

NO NUCLEAR WAR

Peter Tosh

CBS | 1987 | Cover illustration: Neville Garrick

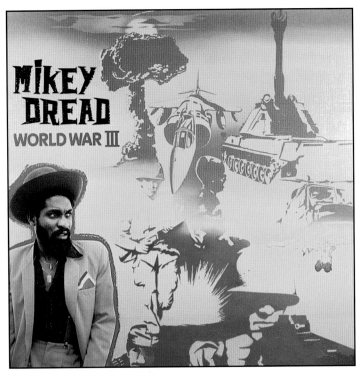

WORLD WAR III

Mikey Dread

Dread At the Controls | 1980 | Cover photo: Adrian Boot | Cover design: George Lawrence

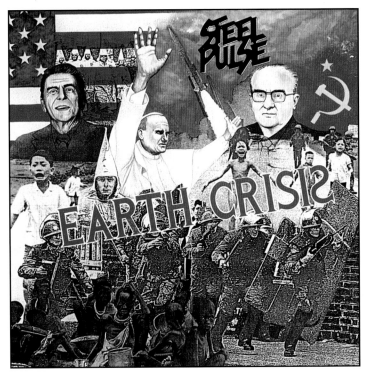

EARTH CRISIS

Steel Pulse

Elektra | 1984 | Cover illustration: Neville Garrick

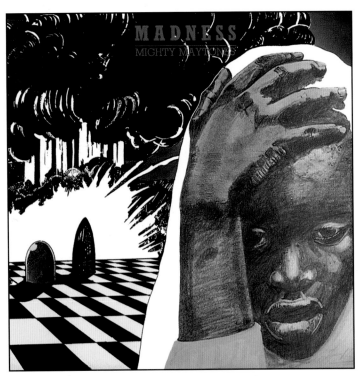

MADNESS

Mighty Maytones

Burning Sounds | 1976 | Cover design: Tyrone Whyte

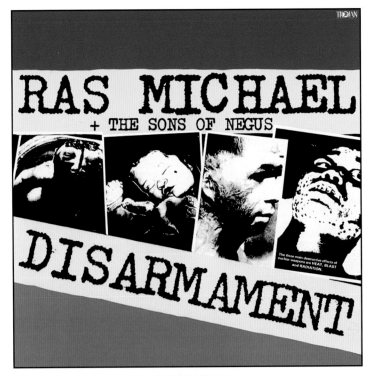

DISARMAMENT

Ras Michael & The Sons of Negus

Trojan | 1981 | Cover design: Bamber Forsyth

Detail from **RIGHTEOUS ARE THE CONQUEROR**

Michael Prophet

Greensleeves | 1980 | Cover design: Tony McDermott

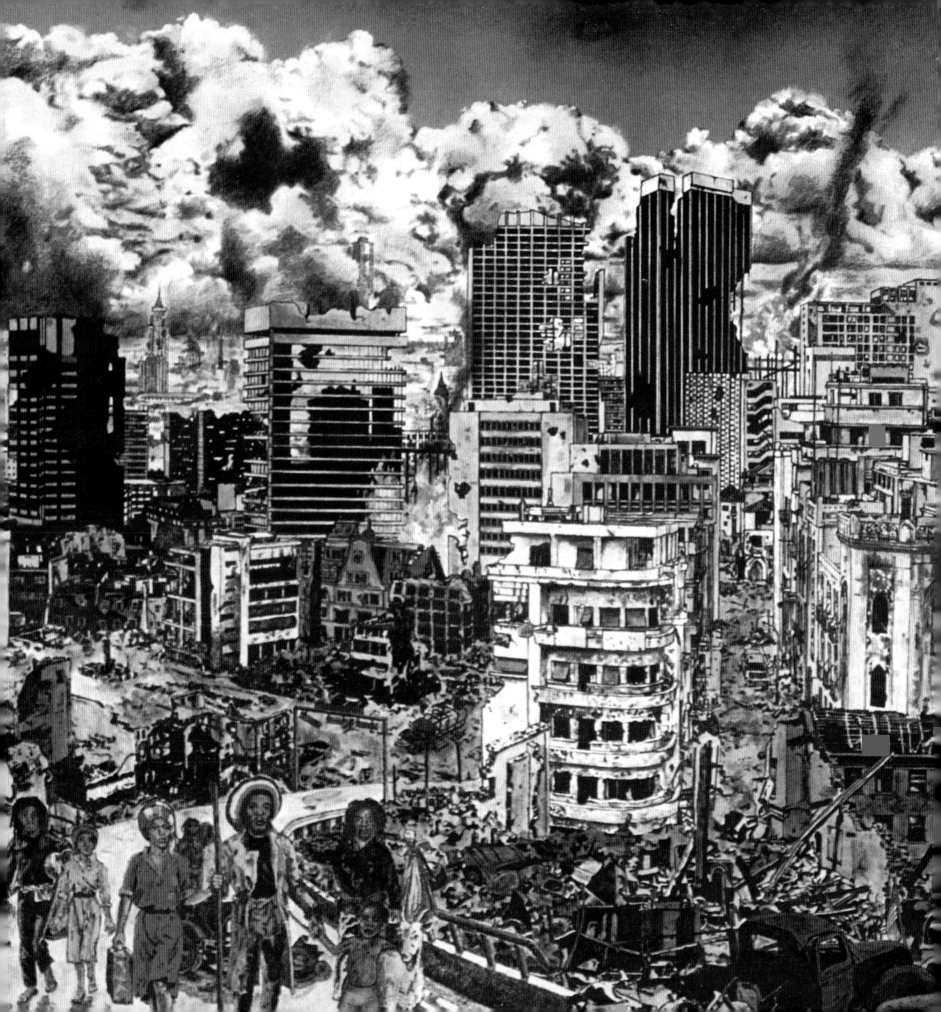

THE HEALING OF THE NATION

Goat Shit. Lambs' Bread. Jerusalem Bread. Marijuana. Sensi. Ganja. Weed of Wisdom. Healing of the Nation. I-shence. Kaya. Herb. Collie.

Known in Jamaica by many names, ganja (*Cannabis sativa*) has become internationally associated with reggae. Scores of album covers fed this perception, as they celebrated the herb being smoked in chalices, rolled in spliffs, or majestically growing in fields.

Ganja was first popularized in Jamaica by the indentured servants brought to the island from the East Indies to work the sugar-cane plantations after slavery was outlawed in the 1840s. Cannabis had been used for centuries in India (the word "ganja" is Hindi in origin), where it was widely respected for its meditative and medicinal qualities. Ironically, the British were the first to commercialize ganja in Jamaica, importing it in bulk for sale to the workers. The British even offered government subsidies to Jamaican planters for growing the crop, hoping to break Russia's monopoly on cannabis, then used in making ropes. By 1924, when the British outlawed the mass sale of cannabis in accordance with a League of Nations treaty, it had already become popular in large sections of Jamaican society.

Though Rastafarians are not the only Jamaicans who've smoked ganja, they're certainly its most conspicuous advocates. Rastafarians regard ganja as a religious sacrament, believing it increases one's meditative powers and enhances consciousness. Not surprisingly, as Rastafarians' visibility increased in reggae, so did ganja's. From the early '70s onward, ganja became a frequent image on reggae album sleeves. These covers served a dual role, as they not only acknowledged a Rastafarian culture, but acted as an excellent marketing tool in selling records to international audiences. Ganja covers had an obvious appeal to the international white rock audience that many reggae labels were anxious to court. From Boston to Birmingham to Berlin, there was no surer way to grab a college student's attention than with a shot of a defiant Peter Tosh lounging in a lush field of ganja, or a red-eyed U-Roy taking outrageous draws from a smoking chalice.

While the visual bravado of these covers certainly helped cement reggae's international reputation as a "rebel" music, it also brought plenty of unwanted attention in Jamaica. Many reggae luminaries, such as Peter Tosh, Bunny Wailer, and Toots Hibbert, spent time in jail for the possession of ganja, their advocacy of the herb being used in the government's decades-old war with the seditious Rastafarians.

Opposite page: **LEGALIZE IT**

Peter Tosh

CBS | 1976 | Cover photo: Lee Jaffe

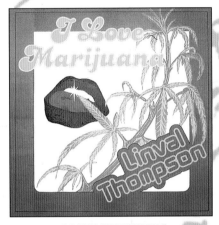

I LOVE MARIJUANA

Linval Thompson

Trojan | 1978

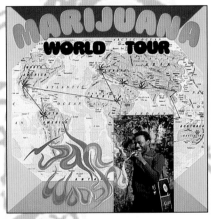

MARIJUANA WORLD TOUR

Jah Woosh

Original Music | 1978

Cover design: Orville Hutchings

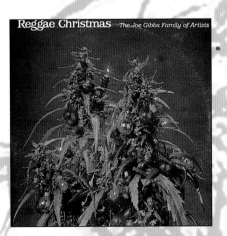

REGGAE CHRISTMAS

The Joe Gibbs Family of Artists

Joe Gibbs Music Co. | 1982 | Cover design: Rob Vaughn

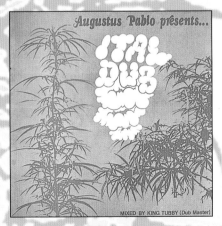

ITAL DUB

Augustus Pablo

Trojan | 1975 | Cover design: Everton Mead

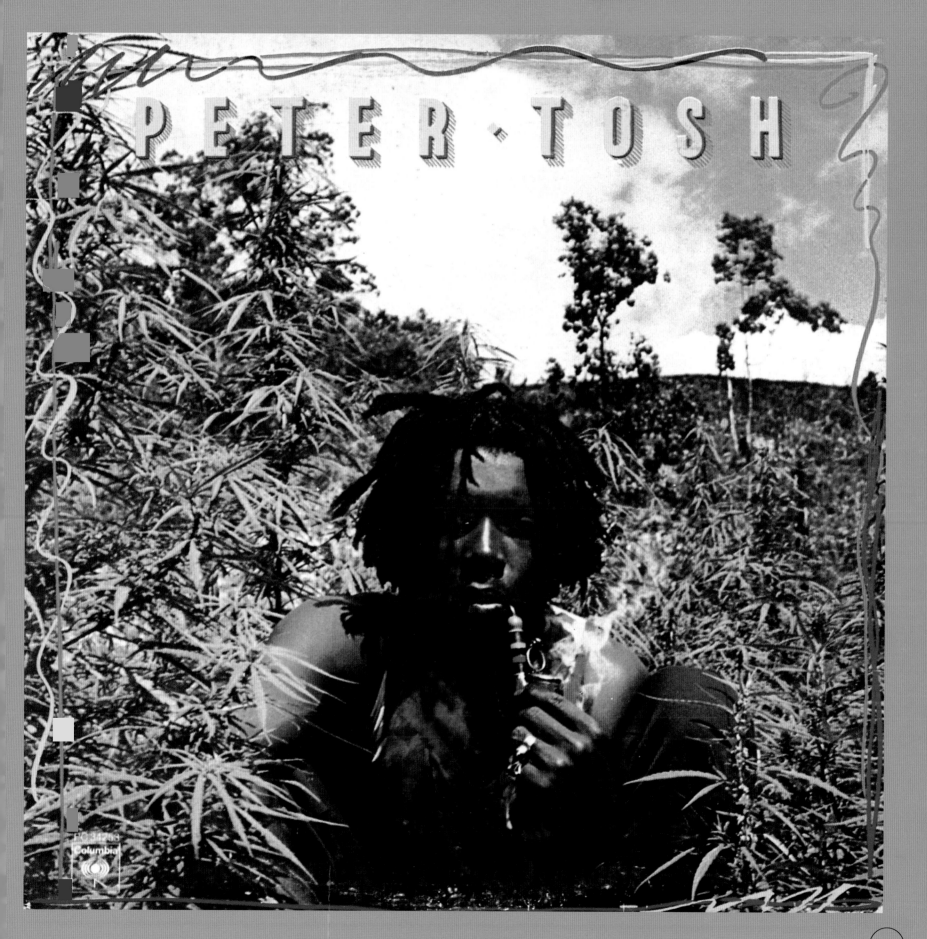

PETER·TOSH

FC 34253
Columbia

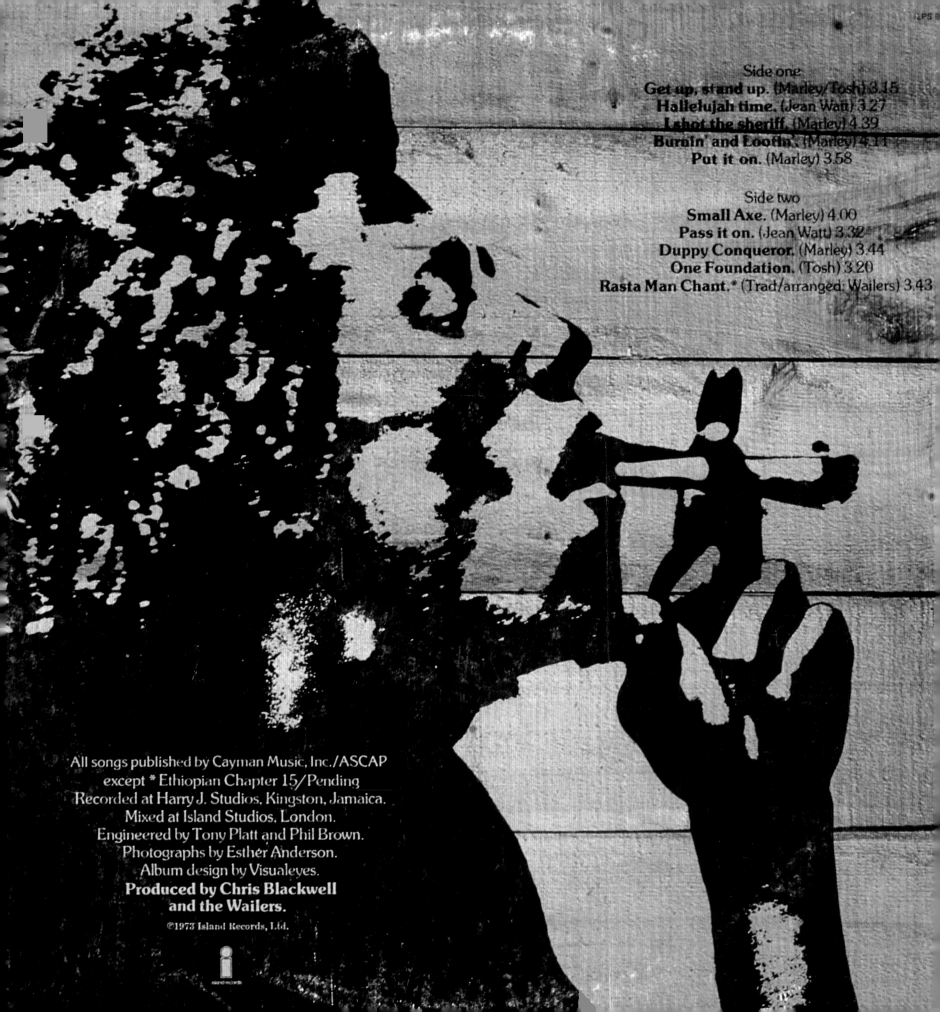

Side one
Get up, stand up. (Marley/Tosh) 3.15
Hallelujah time. (Jean Watt) 3.27
I shot the sheriff. (Marley) 4.39
Burnin' and Lootin'. (Marley) 4.11
Put it on. (Marley) 3.58

Side two
Small Axe. (Marley) 4.00
Pass it on. (Jean Watt) 3.32
Duppy Conqueror. (Marley) 3.44
One Foundation. (Tosh) 3.20
Rasta Man Chant. * (Trad/arranged: Wailers) 3.43

All songs published by Cayman Music, Inc./ASCAP
except * Ethiopian Chapter 15/Pending
Recorded at Harry J. Studios, Kingston, Jamaica.
Mixed at Island Studios, London.
Engineered by Tony Platt and Phil Brown.
Photographs by Esther Anderson.
Album design by Visualeyes.
**Produced by Chris Blackwell
and the Wailers.**

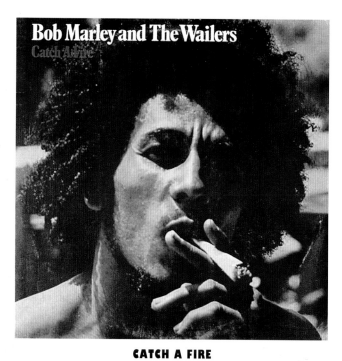

CATCH A FIRE

Bob Marley and The Wailers

Island | 1974 | Cover design: John Bonis of CCS | Cover photo: Esther Anderson

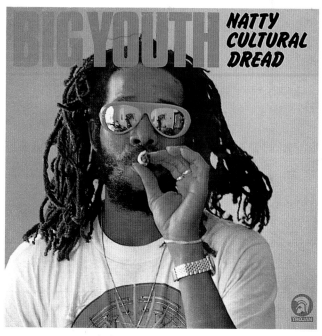

NATTY CULTURAL DREAD

Big Youth

Trojan | 1976 | Cover Design: Dennis Morris

Detail from back cover

DREAD IN A BABYLON

U-Roy

Virgin | 1975 | Cover photo: Eric Tello

Cover design: Ken Dolman

Back cover **BURNIN'**

Bob Marley and The Wailers

Island | 1973 | Cover design: Visualeyes

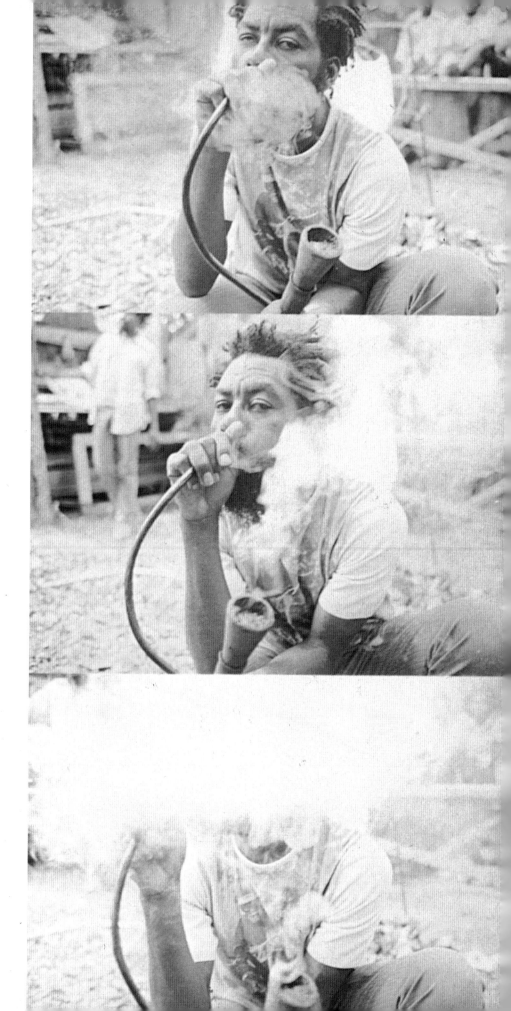

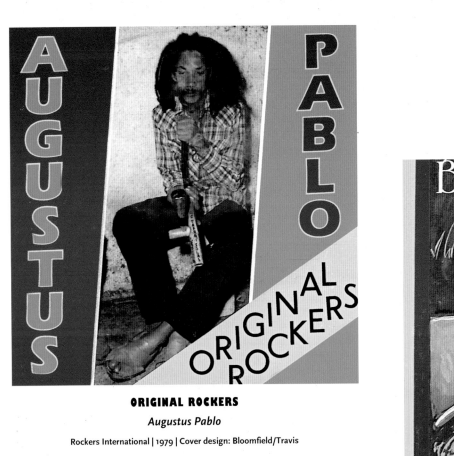

ORIGINAL ROCKERS

Augustus Pablo

Rockers International | 1979 | Cover design: Bloomfield/Travis

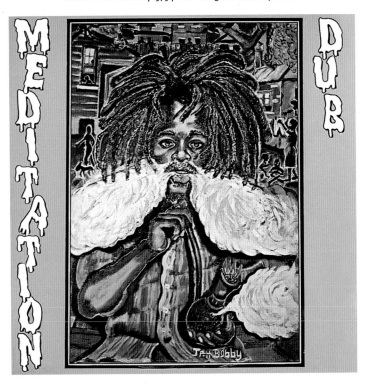

MEDITATION DUB

Winston Riley Productions

Techniques | 1976 | Cover illustration: Jah Bobby

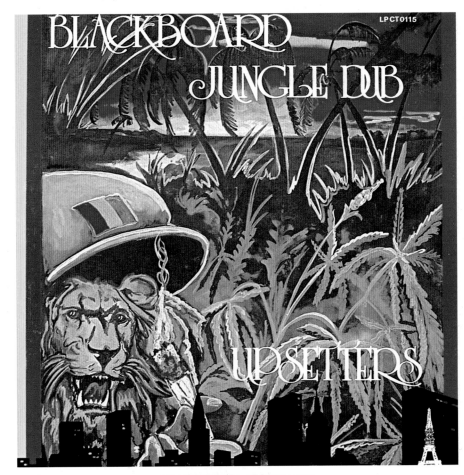

BLACKBOARD JUNGLE DUB

Upsetters

Clocktower | *c.* 1979

MARKETPLACE

Bunny Wailer

Solomonic | 1986 | Cover design: Neville Garrick | Cover illustration: George Hay

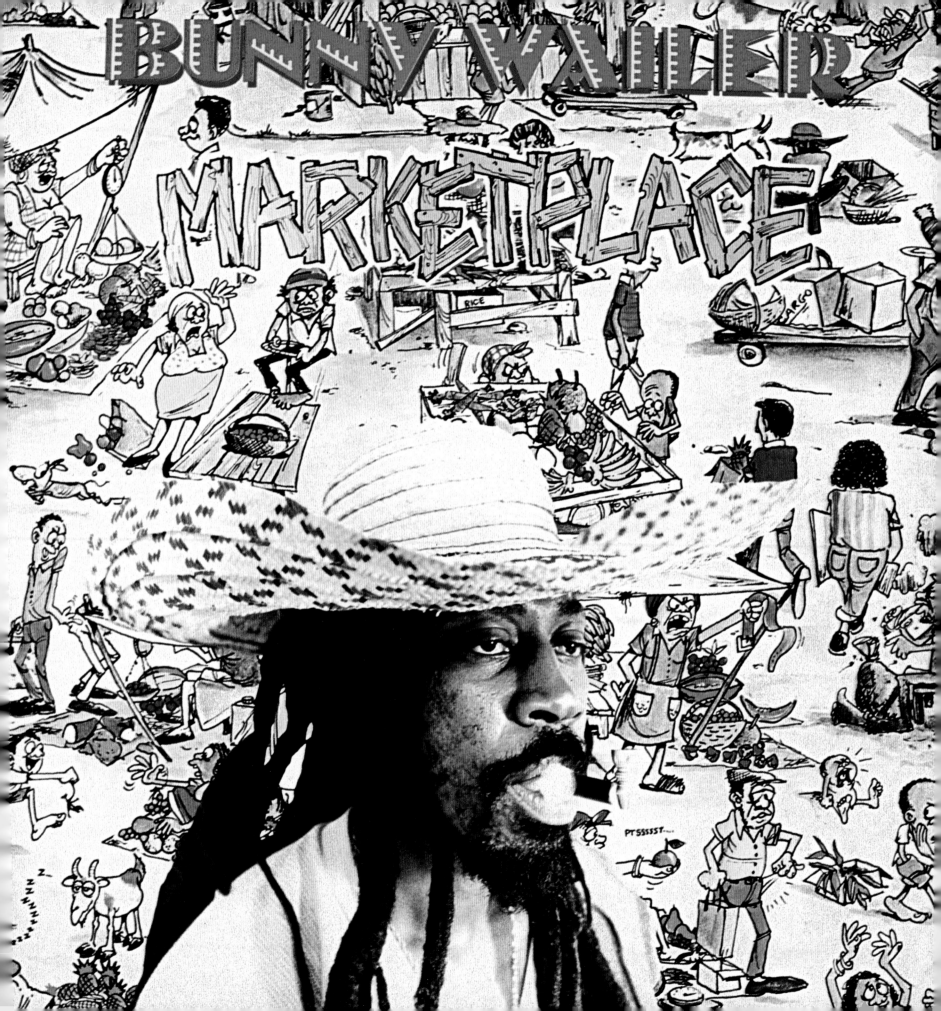

THE GOOD, THE BAD, AND THE UPSETTERS

In the '60s, Jamaica was a nation with no television industry of its

own, forcing it to rely on the United States for most of its screen

entertainment. As is often the case when American movies are

exported, the island received a steady diet of films short on

refinement and long on action and cowboys. These films were

enthusiastically embraced by Jamaicans, especially the working class

of Kingston, who became serious connoisseurs of the spaghetti

Westerns made by directors like Sergio Leone and Sergio Corbucci.

By the late '60s Kingston open-air movie theaters, such as the

Majestic and the Regal, would be packed for Western double features,

with the more emotional fans in the audience sometimes saluting

on-screen heroics with live gunshots. Legend has it that one theater

was forced to show films on a cement screen after its regular one had

been filled with bullet holes after one too many Westerns.

Naturally, Jamaicans' love of action films and Westerns was reflected in reggae, and many of the top artists began to adopt the names of their celluloid heroes. Casually blurring the line between on-screen fantasy and reality, aspiring singers and DJs recorded under names like Clint Eastwood, Josey Wales, Gregory Peck, The Lone Ranger, and Lee Van Cliff. Movie-inspired covers also flourished, with LPs like *Eastwood Rides Again* and *The Good, The Bad & The Upsetters* placing American Westerns in delightfully absurd Jamaican contexts. As Hollywood tired of Westerns and turned to sci-fi films in the '70s, reggae album covers reflected the change. Again, cover designers couldn't resist the temptation to "reggaeize" Hollywood's latest trends, resulting in covers that even featured dreadlocked adventurers doing their best Harrison Ford imitations (*Raiders of the Lost Dub*).

Ironically, Jamaica's reliance on American movies was interrupted by a string of reggae-themed films shot on the island which offered reggae's international fans a window into the music's culture, but also gave Jamaicans a rare chance to see their world represented on screen. The most successful, Perry Henzell's *The Harder They Come,* was released in 1973. It took the outlaw iconography of the American Western and recreated it in a Jamaican setting, using actors and musicians from Kingston. This was the most popular movie ever made about reggae, and served as an introduction to reggae culture for many Americans and Europeans. After Bob Marley's albums, the sleeve for the soundtrack album for *The Harder They Come* is the reggae cover most recognizable to international audiences.

THE HARDER THEY COME
Soundtrack

Island | 1972 | Cover design: CCS Advertising

Background: detail from
HUNTER MAN
Barrington Levy
Burning Sounds | 1983 |
Cover Illustration: Earl Neish

Detail from **THE GOOD, THE BAD & THE UPSETTERS**
The Upsetters
Trojan | 1970 | Cover photography: Dezo Hoffman

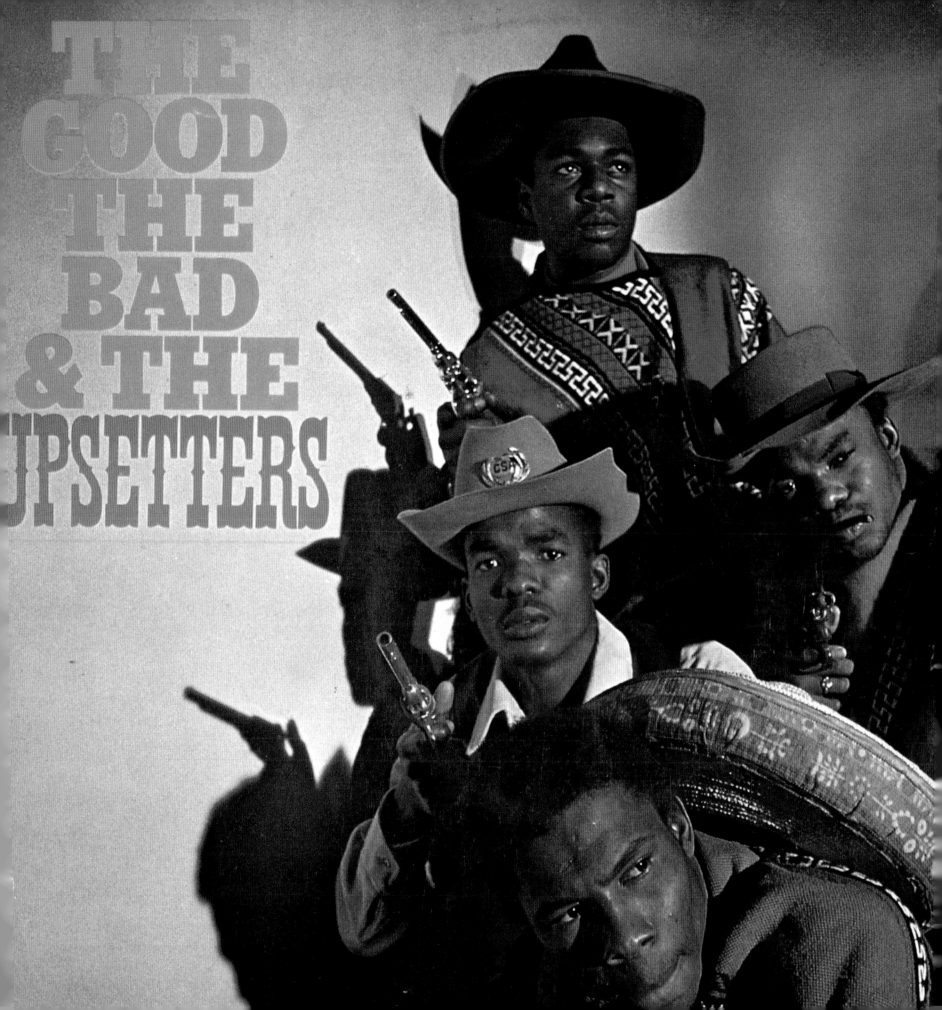

THE GOOD THE BAD & THE UPSETTERS

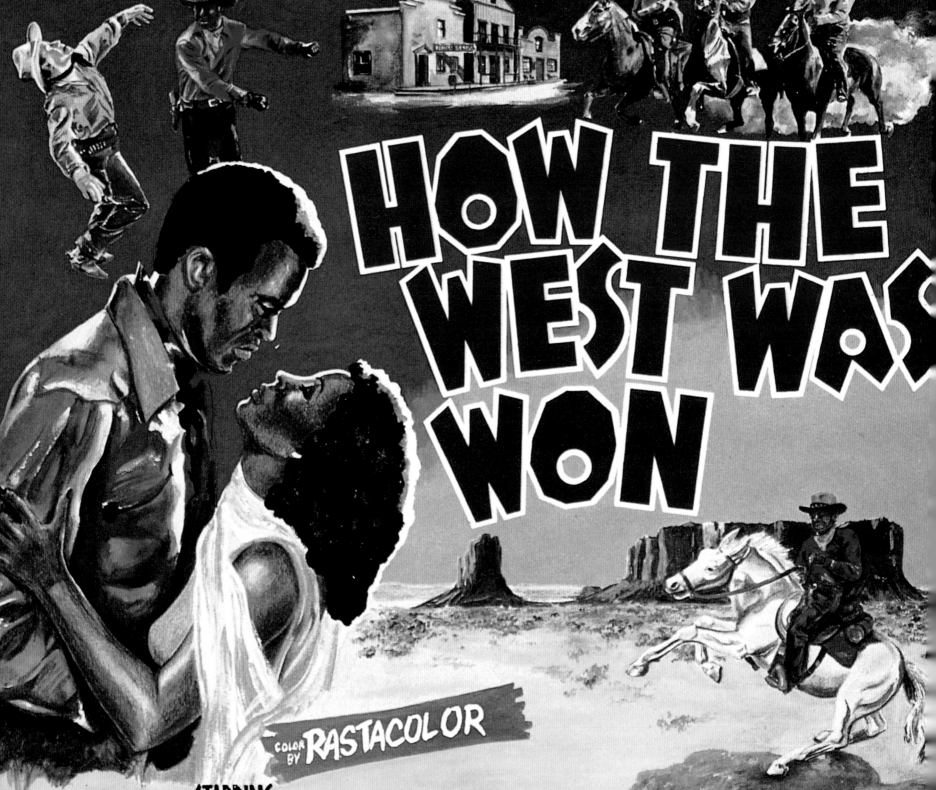

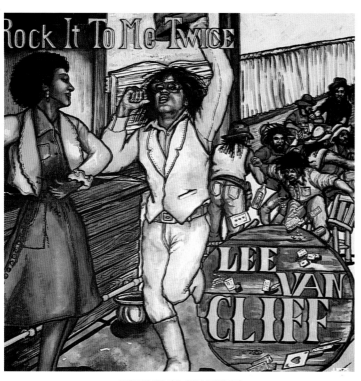

ROCK IT TO ME TWICE

Lee Van Cliff

J&L | 1982

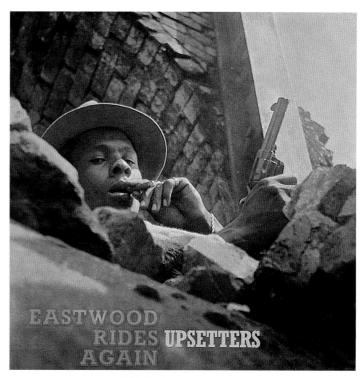

EASTWOOD RIDES AGAIN

The Upsetters

Trojan | 1970

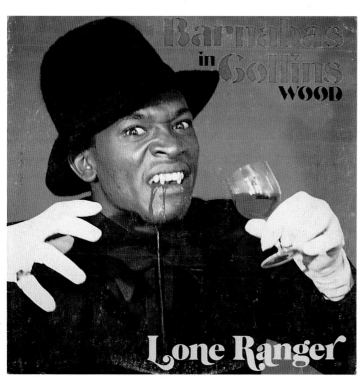

BARNABAS IN COLLINS WOOD

Lone Ranger

G&G | 1979 | Cover design: Hazel Ellis

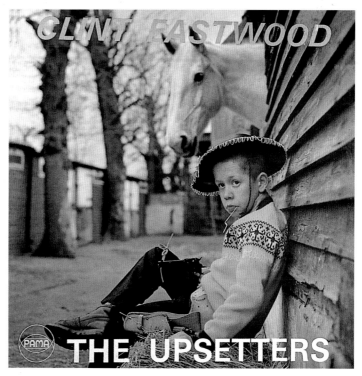

CLINT EASTWOOD

The Upsetters

Pama | 1969

HOW THE WEST WAS WON

Toyan

Greensleeves | 1981 | Cover design: Tony McDermott

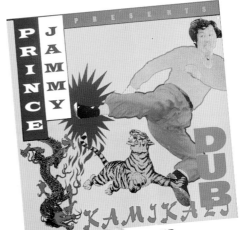

KAMIKAZE DUB

Prince Jammy

Trojan | 1979

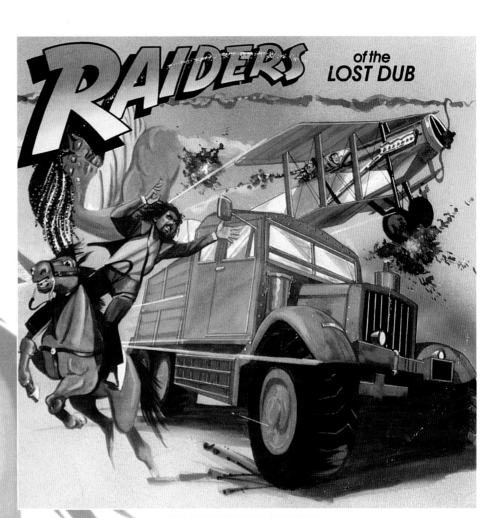

RAIDERS OF THE LOST DUB

Sly & Robbie

Mango | 1981 | Cover illustration: Nino Bukhari

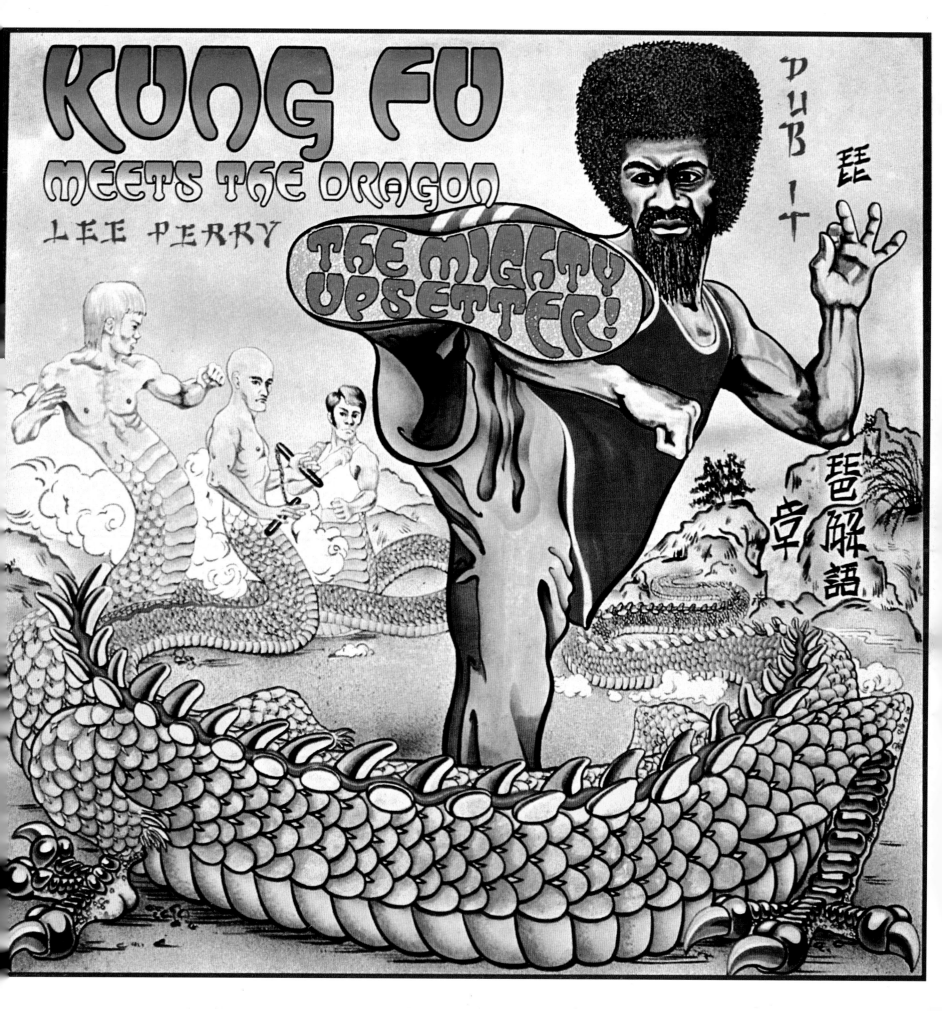

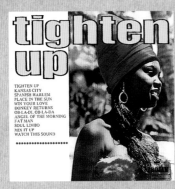

TIGHTEN UP

Various artists

Trojan | 1969

Cover design: CCS Advertising

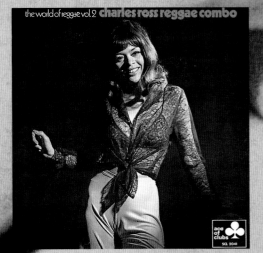

THE WORLD OF REGGAE, VOL. 2

Charles Ross Reggae Combo

Ace Of Clubs | 1970 | Cover photo: David Wedgbury

Background: detail from:

TIGHTEN UP VOLUME 2

Various artists

Trojan | 1969 | Cover design: CCS Advertising

THE SISTREN

Women have been portrayed in many different ways in reggae album cover art, though initially they were cast mainly as alluring marketing images. This trend developed in the '60s, during the heyday of ska and rocksteady. Typical covers featured either bikini-clad beauties (playing on Jamaica's advertised image as a tourist's paradise), or light-skinned go-go girls giving wooden demonstrations of ska dance steps. But after the British tabloid newspaper the *Sun* improved its circulation with the topless "Page Three Girl," British reggae labels were quick to capitalize on similarly sexually suggestive images to market their records.

The most notorious examples of this strategy were the covers for Trojan's *Tighten Up* LPs, which were developed as a budget series of rocksteady and reggae compilations. Despite the presence of many classic tracks, the series' immediate attraction lay in its covers, which featured beautiful women in various stages of undress. While these covers might have contributed little to reggae's artistic legacy, they unquestionably played an important role in breaking the music overseas. Ask any aging male British reggae fan what reggae covers they remember from their youth and the honest ones will reply, "*Tighten Up!*"

As reggae developed a distinct personality in the mid '70s, so did the women on its album covers. On The Wailers' *Soul Rebels*, a machine-gun-toting model sports a militant, independent attitude along with an unbuttoned fatigue shirt. Although the cover was still suggestive, it also demonstrated that album covers were gradually presenting more powerful images of women. In fact, it was Bob Marley's trio of backup singers, Rita Marley, Marcia Griffiths, and Judy Mowatt—the I-Three—who helped break the portrayal of women as stereotypes in reggae cover art. All talented performers in their own right, their solo LPs announced women's presence in the Rastafarian culture that was sweeping reggae. Covers such as Rita Marley's *Who Feels It Knows It* possess a natural beauty, and heralded a new vision of women's dignity. Building on the I-Three's groundwork, artists like Sister Carol would grace covers with all the strength and authority of their reggae brethren.

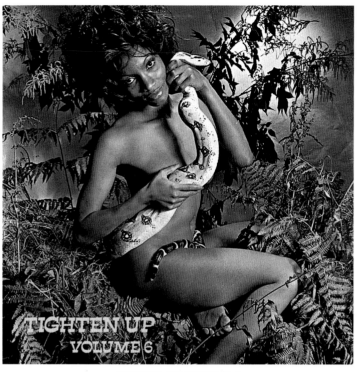

TIGHTEN UP VOLUME 6

Various artists

Trojan | 1972

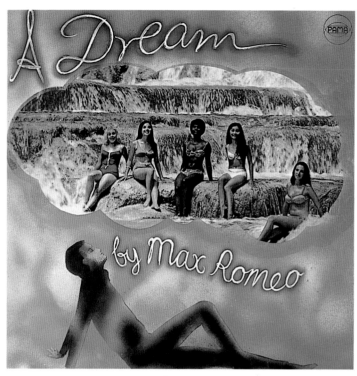

A DREAM

Max Romeo

Pama | 1969 | Cover design: Carl and Jeff Palmer

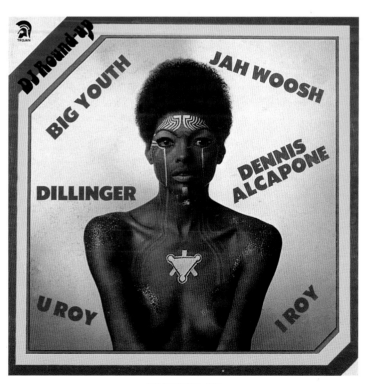

DJ ROUND-UP

Various artists

Trojan | 1976

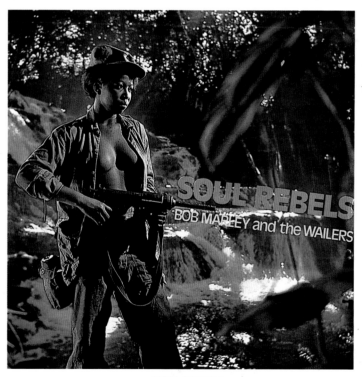

SOUL REBELS

Bob Marley and The Wailers

Trojan | 1970 | Cover photo: Ged Grimmel | Cover design: CCS Advertising

HOT
SHOTS
OF
REGGAE

TIGHTEN UP
volume 3

Left and below left: pull-out poster

TIGHTEN UP VOLUME 3

Various artists

Trojan | 1970

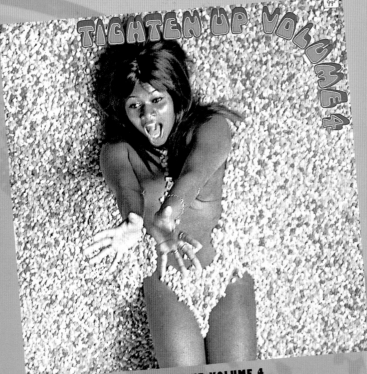

TIGHTEN UP VOLUME 4

Various artists

Trojan | 1971

002 DUB SERIES

pleasure dub

PLEASURE DUB

Various artists

Sun Plum | 1978

HOT SHOTS OF REGGAE

Various artists

Trojan | 1970 | Cover photo: Ged Grimmel

Cover design: CCS Advertising

Judy Mowatt

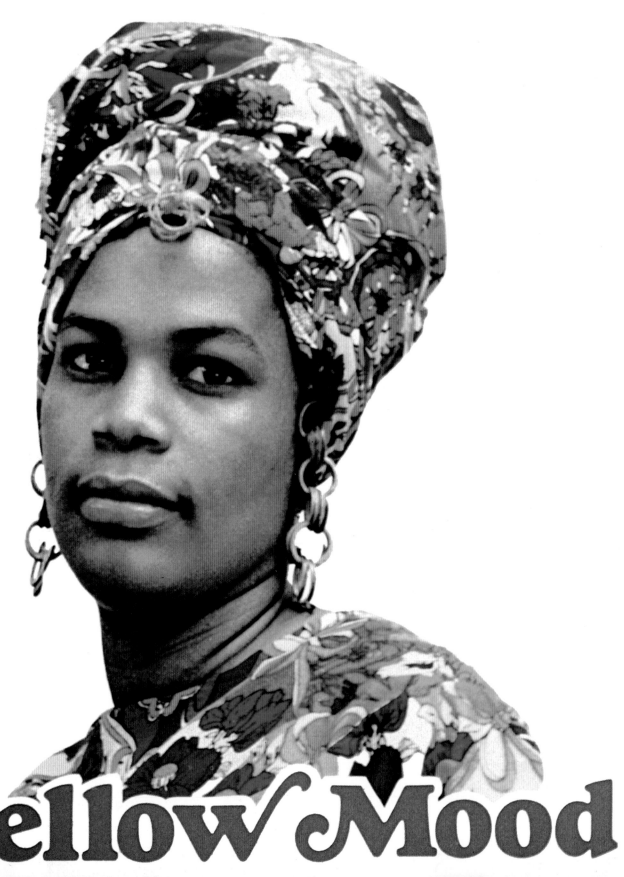

Mellow Mood

Background: detail from
SWEET BITTER LOVE
Marcia Griffiths

Trojan | 1974

Opposite:
MELLOW MOOD
Judy Mowatt

Tuff Gong | 1975 | Cover design: Neville Garrick

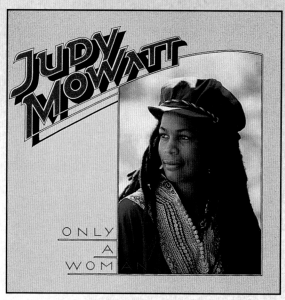

ONLY A WOMAN
Judy Mowatt

Shanachie | 1982 | Cover design: Anita Karl

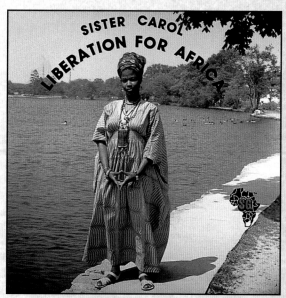

LIBERATION FOR AFRICA
Sister Carol

Serious Gold | 1983 | Cover photo: Errol Roper

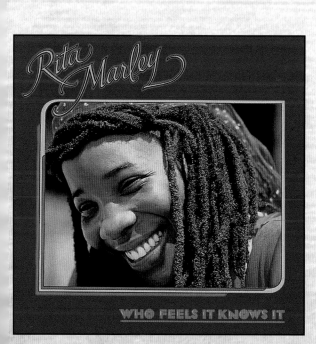

WHO FEELS IT KNOWS IT
Rita Marley

Shanachie | 1981 | Cover design: Anita Karl

DANCING SHOES

Ever since the likes of Coxsone Dodd, Vincent "King" Edwards, and Duke Reid began drawing crowds by playing R & B on their mobile sound-systems, dancing has been the cornerstone of reggae. With respect to the lyrics of many artists, a record's danceability was often the true measure of its popularity among reggae audiences. Not surprisingly, dancing has been a popular theme in reggae cover art.

Most of the early covers depicting dances were fairly tame, choosing to overlook some of the dancehalls' more unpleasant elements. In addition to plenty of music, food, and liquor, the early dancehalls also saw periodic flashes of violence—members of competing sound-systems would often crash their rivals' dances, destroying records and "mashing up" the site.

While covers hyping fictitious steps like the "ska" and "rocksteady" suggested the type of dancing favored on the TV show *American Bandstand*, authentic Jamaican dances were much more gritty. In time, covers like *The Seducer* would come to reflect the passionate, sensual vibe of the reggae dancehall. And when roots reggae gave way to the aptly named "dancehall" style in the mid-'80s, these dances again took centerstage. The sleeve for the compilation *Hypocrite* reflects the popular trend of styling covers after the posters that advertised upcoming dances. The sleeve for *Sleng Teng Extravaganza* captures all the energy and action of a dancehall in the mid-1980s, while at the same time satirizing some of the dancehall's more conservative depictions in the formally attired couple in the upper right-hand corner.

The style of reggae known as "dancehall" emerged during the early 1980s, its name referring to the venue where it had its initial success, the Jamaican dancehall. While the early '80s found many of reggae's established acts courting international audiences, this new sound was firmly grounded in Jamaica. The dancehall sound was characterized by a stripped-down approach, with the emphasis on the drum and bass. Dancehall's raw, rhythmic feel was echoed in the covers from this period, which were often more stark and simplistic than their roots predecessors. The socially themed roots covers might have been more palatable to international audiences, but dancehall's covers returned the focus to reggae's birthplace—Jamaica's streets and dancehalls.

Dancehall's covers also helped popularize another of reggae's innovations, the DJ clash. DJs, artists who would rhythmically chant over instrumental records, had been a feature of Jamaican dances since the '60s. DJs would perform exclusively for individual sound-systems, with followers of different "Sounds" often arguing over the superiority of their own DJs. The rivalries were often resolved live with DJs clashing before dancehall crowds who decided the winner. These clashes were soon taken to the studio, with the opposing DJs each getting a side of the record to showcase their skills. The covers of these albums played up the concept of a musical battle, portraying the performers going head to head. In reality, these clash albums were rarely acrimonious affairs, but represented opportunities for labels to sell more albums by featuring two artists. Still, the image of DJs facing off became a staple of subsequent reggae jackets, and would also influence American hip-hop, which would adopt its own version of the DJ clash—the MC battle.

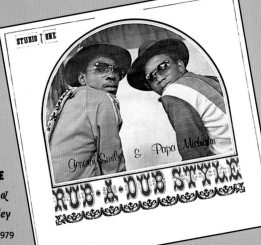

REGGAE IN THE GRASS
Various artists
Studio One | 1968 | Cover design: CCS Advertising
Cover photo: Jackie Estick

RUB A DUB STYLE
*Papa Michigan &
General Smiley*
Studio One | 1979
Cover design: Glenville Dayle

Background: detail from **ALL STAR TOP HITS**
Various artists
Coxsone | 1961 | Cover design: A. Benjamin

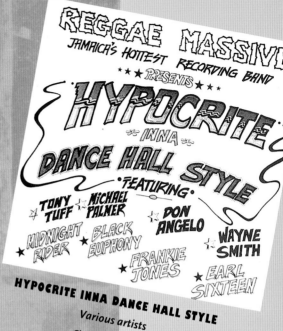

REGGAE MASSIVE
JAMAICA'S HOTTEST RECORDING BAND
★★★ PRESENTS ★★★
"HYPOCRITE"
≈ INNA ≈
DANCE HALL STYLE
·FEATURING·
★ TONY TUFF ★ MICHAEL PALMER ★ DON ANGELO
★ MIDNIGHT RIDER ★ BLACK EUPHONY ★ WAYNE SMITH
★ FRANKIE JONES ★ EARL SIXTEEN

HYPOCRITE INNA DANCE HALL STYLE
Various artists
Channel One | 1984

JUK'S INCORPORATION

Detail from
JUK'S INCORPORATION
Dub Specialist
Studio One | 1975

RCA VICTOR

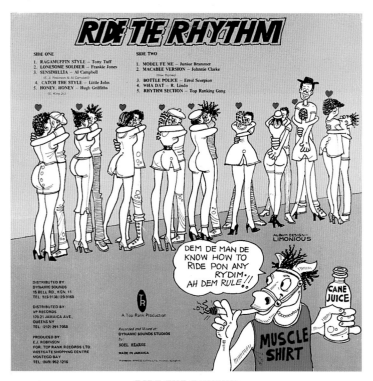

RIDE THE RHYTHM

Various artists

Top Rank | 1985 | Back cover design: Wilfred Limonious

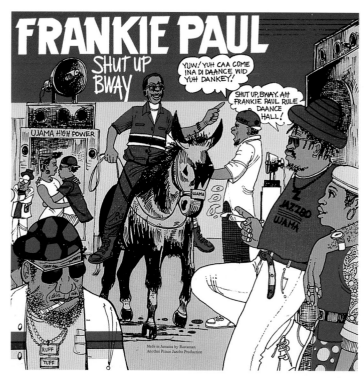

SHUT UP BWAY

Frankie Paul

Ujama | *c.* 1986 | Cover design: Wilfred Limonious

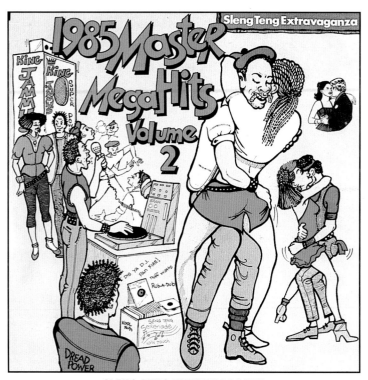

SLENG TENG EXTRAVAGANZA

1985 MASTER MEGA HITS VOLUME 2

Prince Jammy

Jammys | 1985 | Cover illustration: J. Paco Dennis

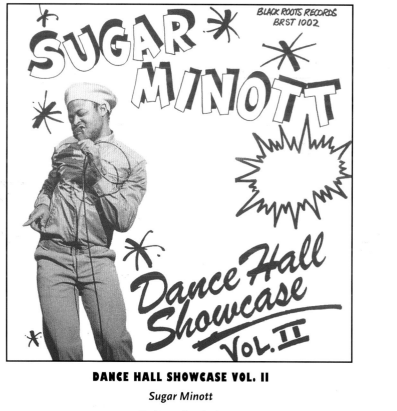

DANCE HALL SHOWCASE VOL. II

Sugar Minott

Black Roots | 10" | 1983

BLUE BEAT

Various artists

RCA | *c.* 1967

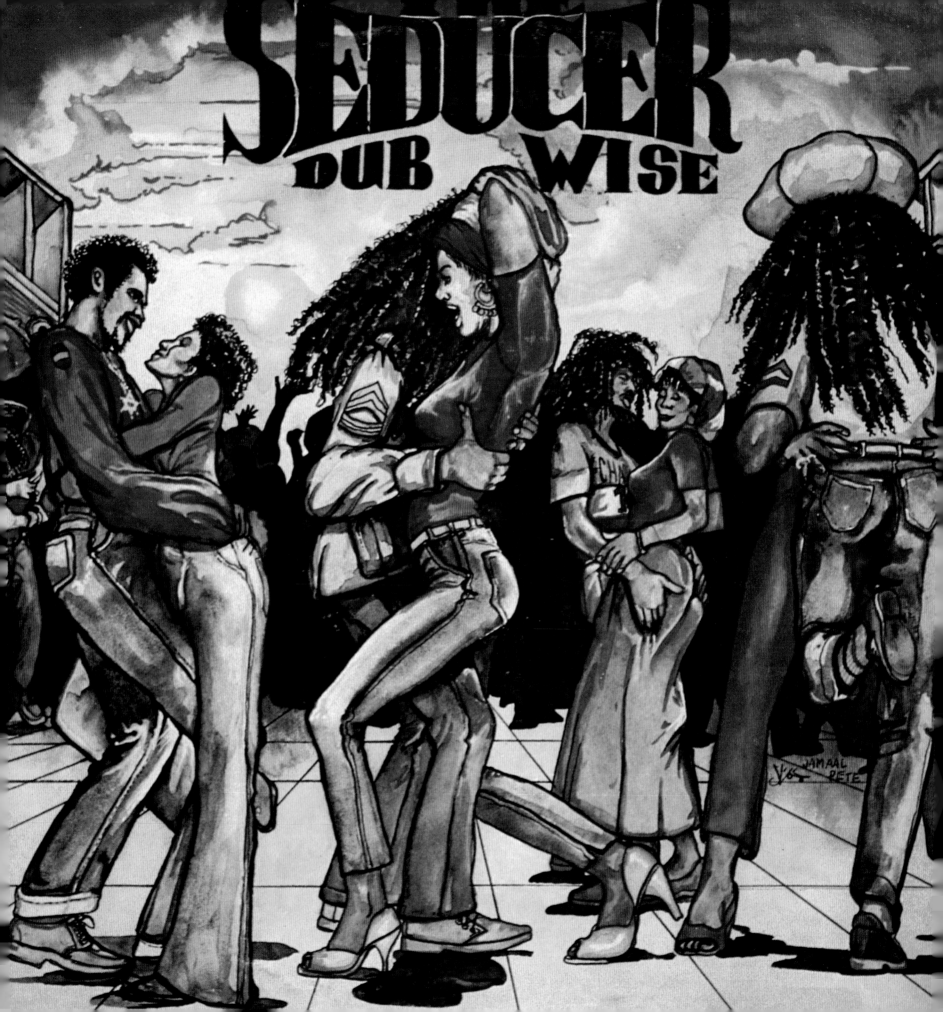

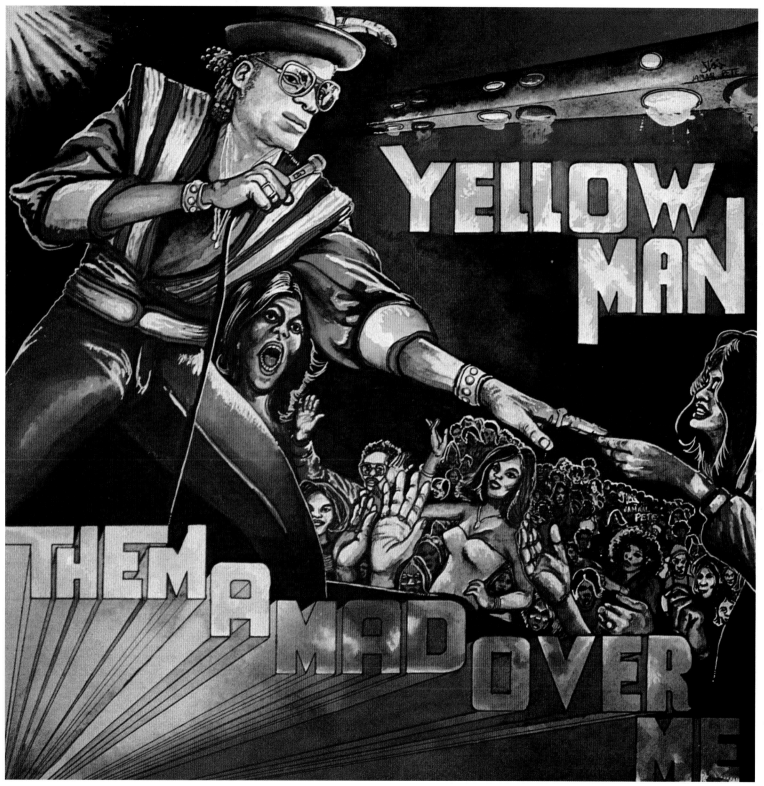

THEM A MAD OVER ME

Yellowman

J&L Records | 1981 | Cover illustrations: Jamaal Pete

THE SEDUCER

Scientist

Channel One | 1982 | Cover illustration: Jamaal Pete

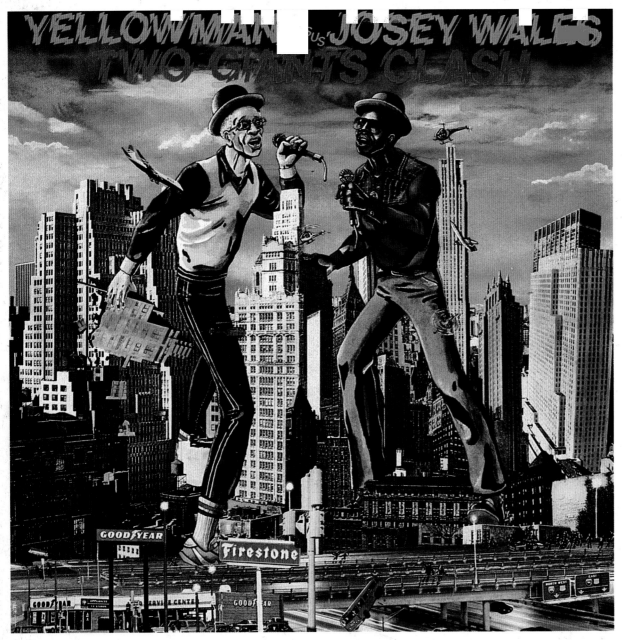

TWO GIANTS CLASH

Yellowman versus Josey Wales

Greensleeves | 1984 | Cover design: Tony McDermott

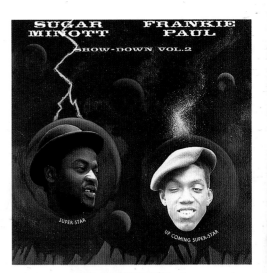

SHOW-DOWN VOL. 2

Sugar Minott & Frankie Paul

Channel One | 1983

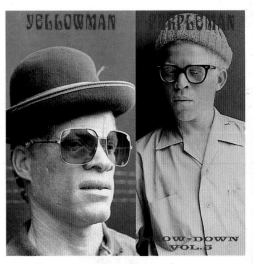

SHOW-DOWN VOL. 5

Yellowman & Purpleman

Empire | 1984

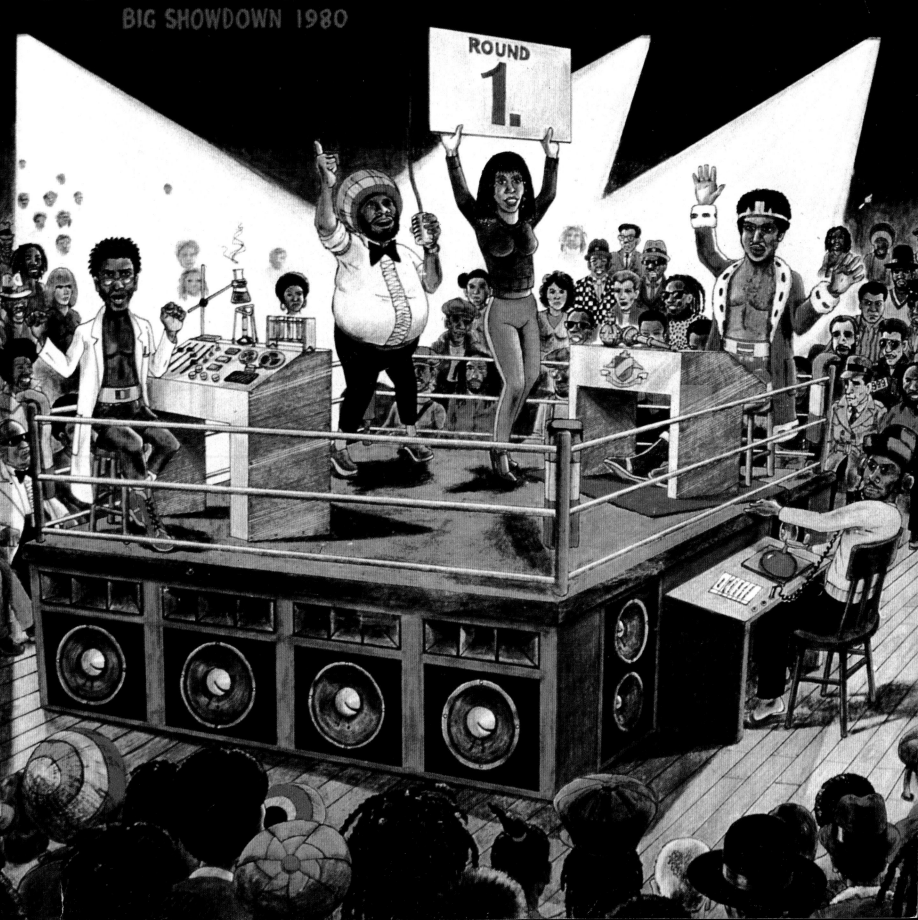

BEHIND THE SLEEVES

Designing album covers has never been a high-profile vocation: Peter Blake and Michael Cooper collaborated on the cover for *Sgt. Pepper's Lonely Hearts Club Band*, perhaps the most recognizable sleeve in pop history, but challenge most people to name the designer and you'll be met with silence. Such a low profile was even more pronounced in reggae, where few designers were able to establish name recognition, and many were not even credited on the jackets they designed. Although designers like Lloyd Robinson, Herman Cain, Dave Fields, and CCS Advertising of London all created a number of extraordinary covers, their output was sporadic. And they were among the more fortunate ones, as many in their field toiled in obscurity.

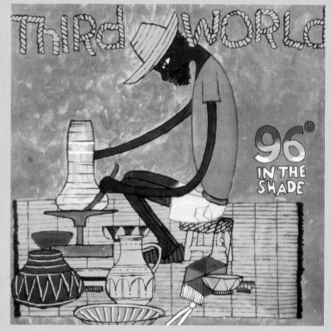

96° IN THE SHADE

Third World

Island | 1977 | Cover illustration: Tony Wright

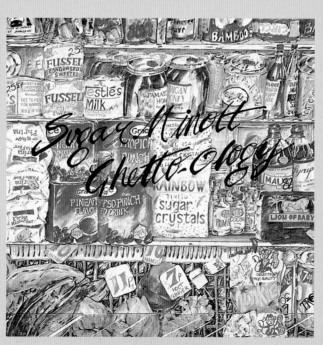

GHETTO-OLOGY

Sugar Minott

Trojan | 1979 | Cover illustration: Conny Jude

Detail from **YOU'LL NEVER KNOW**

Reggae George

Greensleeves | Disco 45 | *c.* 1982 | Cover design: Tony McDermott

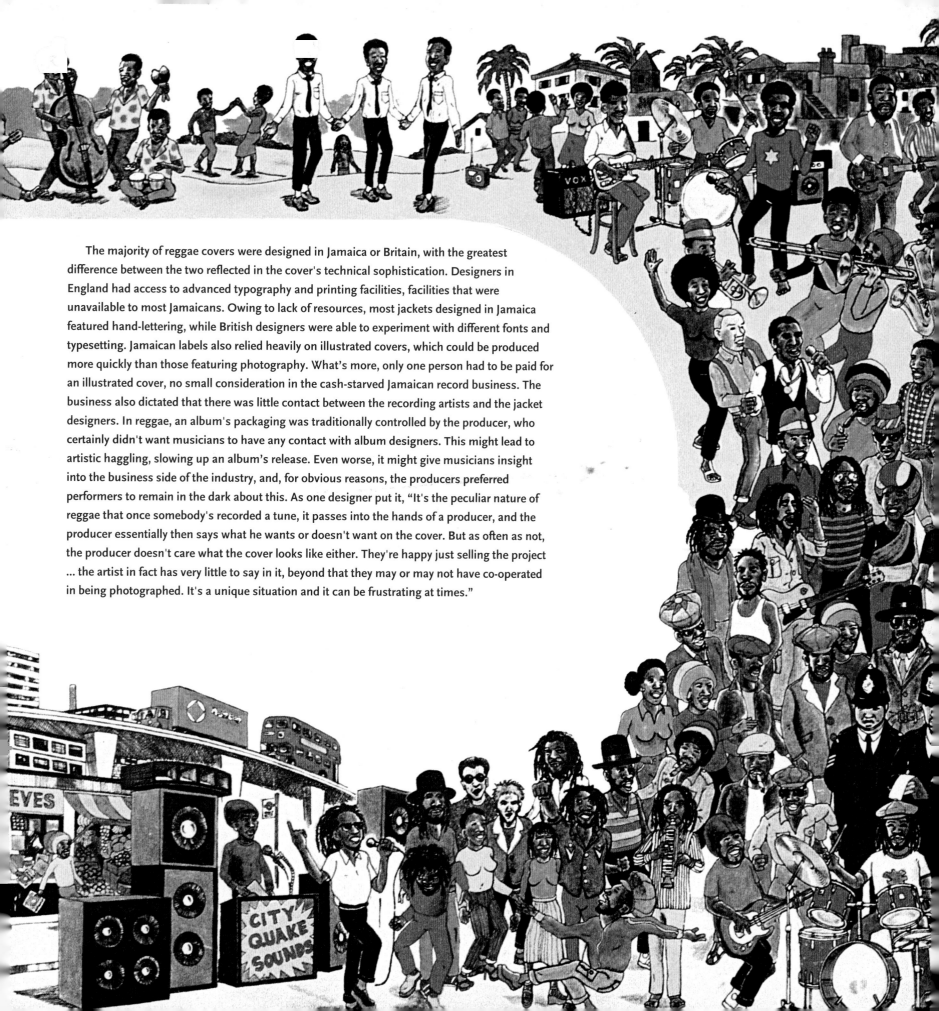

The majority of reggae covers were designed in Jamaica or Britain, with the greatest difference between the two reflected in the cover's technical sophistication. Designers in England had access to advanced typography and printing facilities, facilities that were unavailable to most Jamaicans. Owing to lack of resources, most jackets designed in Jamaica featured hand-lettering, while British designers were able to experiment with different fonts and typesetting. Jamaican labels also relied heavily on illustrated covers, which could be produced more quickly than those featuring photography. What's more, only one person had to be paid for an illustrated cover, no small consideration in the cash-starved Jamaican record business. The business also dictated that there was little contact between the recording artists and the jacket designers. In reggae, an album's packaging was traditionally controlled by the producer, who certainly didn't want musicians to have any contact with album designers. This might lead to artistic haggling, slowing up an album's release. Even worse, it might give musicians insight into the business side of the industry, and, for obvious reasons, the producers preferred performers to remain in the dark about this. As one designer put it, "It's the peculiar nature of reggae that once somebody's recorded a tune, it passes into the hands of a producer, and the producer essentially then says what he wants or doesn't want on the cover. But as often as not, the producer doesn't care what the cover looks like either. They're happy just selling the project ... the artist in fact has very little to say in it, beyond that they may or may not have co-operated in being photographed. It's a unique situation and it can be frustrating at times."

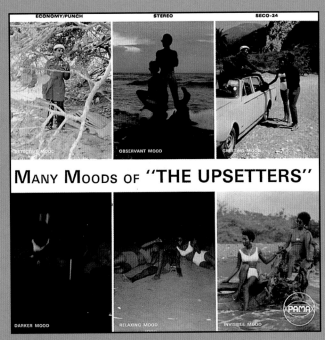

MANY MOODS OF THE UPSETTERS

The Upsetters

Pama | 1970

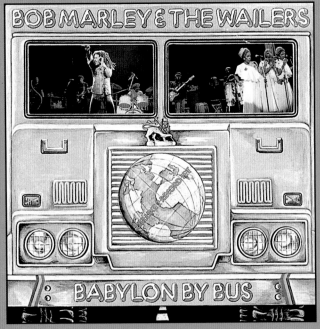

BABYLON BY BUS

Bob Marley & The Wailers

Island | 1978 | Cover design: Neville Garrick

While this system left most performers far removed from the creative process of cover design, established artists were often more involved. When creating covers for well known artists like Lee Perry or Dr. Alimantado, designers at least made sure their sleeves were in tune with the artists' public image. Even though Perry rarely received design credits, throughout his career his covers seemed to capture his vibrant, eccentric personality. The sleeve for *Many Moods of The Upsetters* conveys the playfulness and humor that was so central to Perry's music. And D.K. James's cover photograph for *Best Dressed Chicken In Town* is seen as the ultimate symbol of Dr. Alimantado's peculiar reality. At the other end of the spectrum, the covers for Bob Marley's albums were always faithful in conveying his serious "Dread" persona.

Marley's albums for the Island Record Company featured sleeves that represent reggae cover art's zenith in terms of thoughtfulness, complexity, and corporate support, and most of his Island releases were designed by Neville Garrick. He was one of a handful of designers, who, because they were affiliated with established labels, were able to enjoy prolific and relatively stable careers. Designers like Garrick, Wilfred Limonious, Tony McDermott, Jamaal Pete, and Tony Wright all developed signature illustrated styles which would become hallmarks of reggae cover art.

It was at the suggestion of his former schoolmate Alan "Skill" Cole, Bob Marley's close friend and sometime manager, that Garrick began designing covers for the reggae superstar. Garrick quit his job as art director for a newspaper, and was soon illustrating the cover for Marley's *Rastaman Vibration*. He would go on to design most of the singer's subsequent releases for Island—*Exodus, Kaya, Survival, Babylon By Bus,* and *Confrontation* were all his designs, as were many covers for stars like Peter Tosh, Bunny Wailer, and Burning Spear. Bridging the usual gap between performer and designer, Marley and Garrick enjoyed a close friendship. Garrick even joined the Wailers onstage as a percussionist because Marley felt that the more involved Garrick was with the Wailers' music, the better he could visually interpret it.

Working with a superstar of Marley's stature created marketing issues most reggae designers never had to face. Garrick's original design for *Exodus* portrayed a Rasta updating of Moses parting the Red Sea. He was forced to scrap the sleeve after complaints that his photograph of Marley using a fisheye lens would render Marley's face unrecognizable to his fans.

CONFRONTATION

Bob Marley & The Wailers

Island | 1983 | Cover illustration: Neville Garrick

BOB MARLEY & THE WAILERS CONFRONTATION

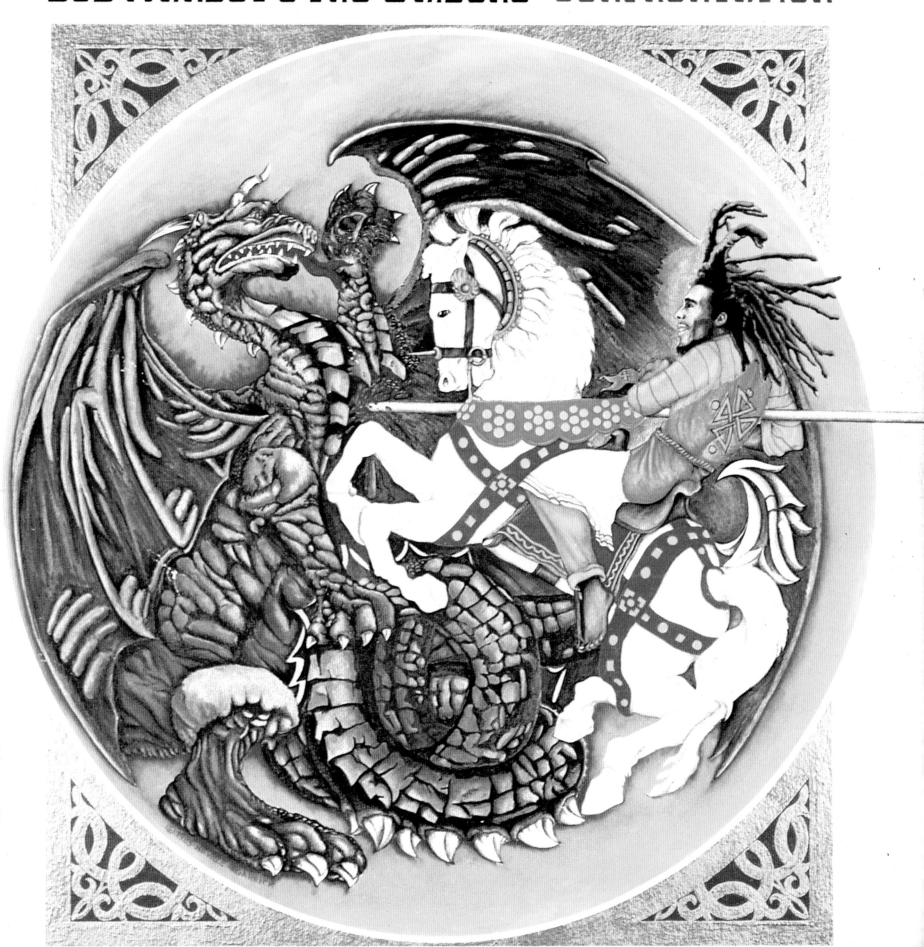

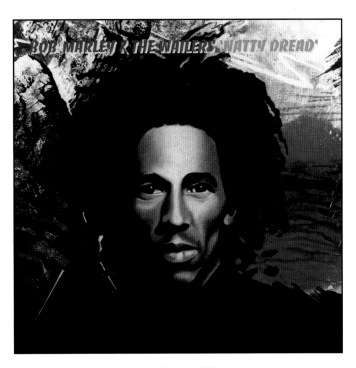

NATTY DREAD

Bob Marley and The Wailers

Island | 1975 | Cover illustration: Tony Wright

Tony Wright, who designed many of Island's reggae covers, faced a similar situation with his illustration for Marley's *Natty Dread*. The background of Wright's first design depicted New York being destroyed in a deluge, adapted from a painting by the nineteenth-century artist John Martin. However, it was thought that the devastation of New York might be too troubling for the mainstream record buyers being courted by Island, and this was ultimately cropped out of the final cover, though you can still just make out the city's skyline toppling in the upper right-hand corner.

Despite the limitations created by marketing concerns, working with artists like Marley and Tosh gave Garrick unprecedented access to international audiences. A devout Rastafarian, Garrick was conscious of the impact his covers carried and made sure they reflected his religious and cultural beliefs. "From going to school at UCLA and coming out of Hollywood, I think my job was to add some showbiz to the whole Rasta thing. All the concepts I'd learned, the design and advertising and marketing, I decided to use that for Rasta instead of to sell Colgate toothpaste."

London-based designer Tony McDermott got his start as a comic-strip illustrator. He soon took his talents to the British labels Greensleeves and Ariwa, where his cartoon-influenced drawings would

grace scores of albums, including those by artists like Scientist and Mad Professor. One of the advantages of illustrated covers is that they allow designers the opportunity to be topical in their subject matter. According to McDermott: "Back then ['70s and early '80s] you'd create artwork and it be on the streets in two or three weeks." McDermott and other artists took full advantage of the industry's hectic pace, creating covers that made references to whatever was hot at the moment. McDermott's cover for *Prince Jammy Destroys the Invaders* featured an '80s pop culture icon, the video game Space Invaders, at the height of its popularity. McDermott remembered, "As for the Space Invaders cover, it was just wacky. Space Invaders was very much a new thing at the time. It was big news. And because it [reggae] is a youth music, whatever the youth fixation was at the time, reflecting it felt like the right thing to do." McDermott's comic illustrations also conveyed the humor and the sense of the absurd that is found in so much reggae music. "There was always that strand in Jamaican music, where there were a lot of comedy records. Of course, there were DJs like U-Roy and Big Youth with very heavy messages, but there were artists who were much more whimsical. And Jamaicans are like that, they like to laugh. Comedy is a big part of Jamaican culture. Nobody ever got offended by that. Nobody ever came back and said, 'We're more serious than you're making us out to be.' We usually tailored to the artist. If somebody had come to us with a serious Dread album, we wouldn't have put a cartoon on it."

While New York-based designer Jamaal Pete's covers were often not as zany as McDermott's, his work for such labels as Studio One, Clocktower, and Channel One still served as vibrant windows into the emerging dancehall scene. Pete's illustrations were able to capture the different moods of reggae, articulating the music's earnest as well as frivolous personalities. His portraits of Haile Selassie are some of the most striking covers that reggae ever produced. Yet he was also at home drawing wild, cocky cartoons of dancehall luminaries like Yellowman and Barrington Levy. A Jamaal Pete cover needed no credit: his distinctive style stood out like a beacon, alerting fans that another set of dancehall smashes were on the way.

One of the most prolific jacket designers from early dancehall was Kingston's Wilfred Limonious. Working for a string of Jamaican labels, including Sonic Sounds and Power House, Limonious's covers featured caricatures of Kingston street culture. Simple to the point of appearing childlike, Limonious's drawings provided a striking contrast to elaborate covers coming from the major British and American labels. His covers should be viewed as examples of Jamaican folk art, sparse illustrations which succeeded in capturing the humor and irony in Jamaica's daily life. Limonious's characters play the horses, dodge bullets, smoke ganja, and chase women in a slapstick style that is as authentic as it is simple.

VERSION GALORE

Big Youth and various artists

Trojan | 1973 | Cover design: Dave Fields

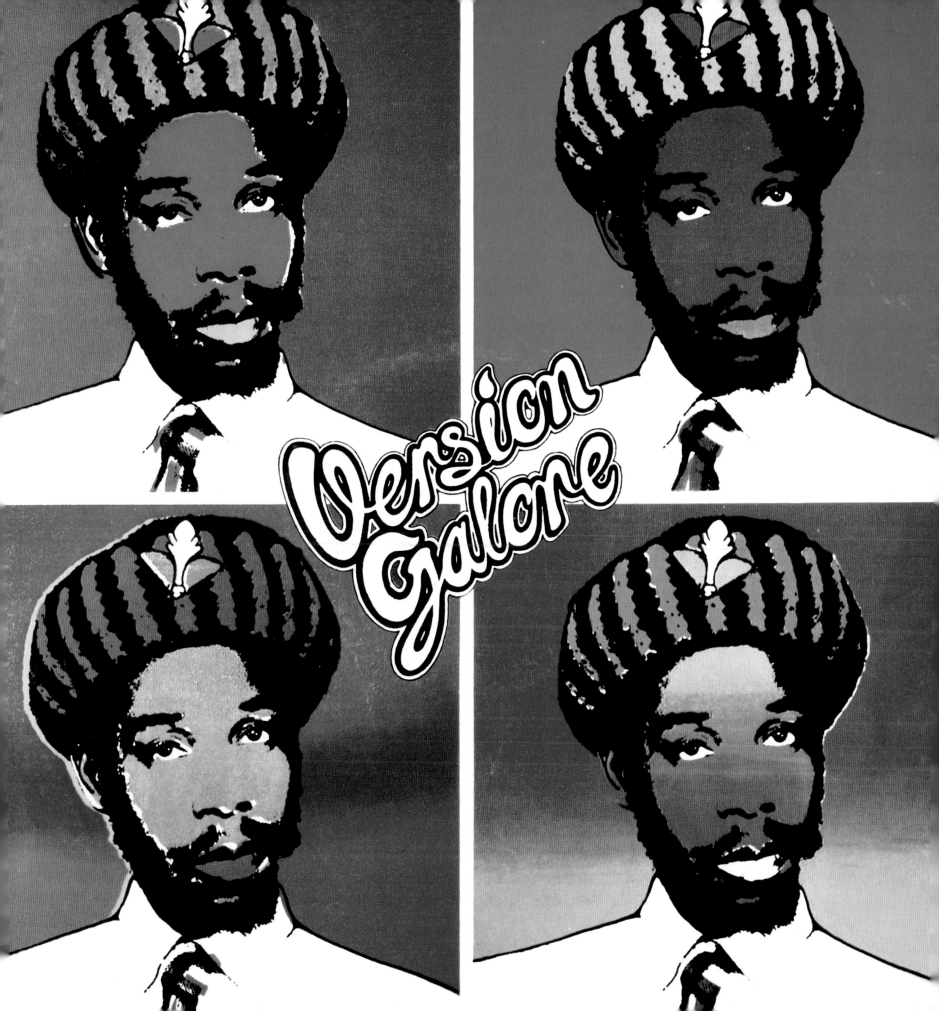

HAILE I HYMN

Ijahman Levi

Island | 1978 | Cover illustration: Tony Wright

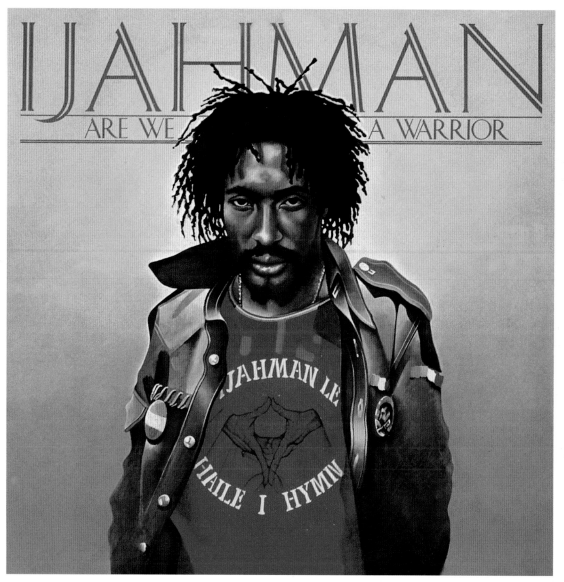

ARE WE A WARRIOR

Ijahman Levi

Mango | 1979 | Cover illustration: Tony Wright

SINSEMILLA

Black Uhuru

Mango | 1980 | Cover illustration: Tony Wright

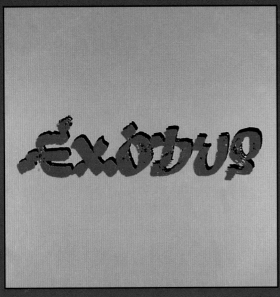

EXODUS
Bob Marley & The Wailers
Island | 1977 | Cover design: Neville Garrick

Neville Garrick: "*Exodus* I liked. *Exodus* was something I worked a long time on and the original design actually wasn't used. It was in the spirit of Moses crossing the Red Sea. So I shot Bob and the whole group using a fisheye lens, and they were kinda of going through this airbrushed lake that was divided with waves and things. And they were all playing percussion and drums, Nyahbinghi drums, with a Haile Selassie backdrop. But Bob's girlfriend of the time, Cindy Breakespeare, didn't like the slight distortion in Bob's face from the fisheye lens. So we decided, at least I decided, since exodus was such a known word, and lent a lot of interpretations, I better try to do something with type. So I came up with the idea of using Ethiopian letters, bastardizing the Aramaic letters to read English. And it turned out to be one of the most successful campaigns."

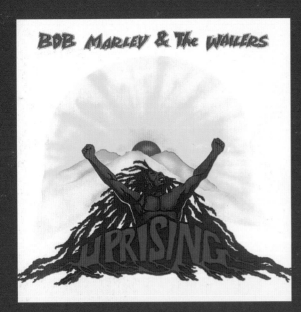

UPRISING
Bob Marley & The Wailers
Island | 1980 | Cover design: Neville Garrick

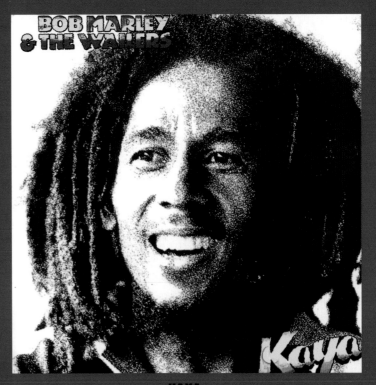

KAYA
Bob Marley & The Wailers
Island | 1978 | Cover design: Neville Garrick

WANTED

SIDE I	SIDE II
1) COMING IN HOT	1) WANTED DREAD & ALIVE
*2) NOTHING BUT LOVE	2) RASTAFARI IS
3) REGGAE-MYLITIS	3) THAT'S WHAT THEY WILL DO
4) THE POOR MAN FEEL IT	4) FOOLS DIE
5) COLD BLOOD	

ARRANGED AND PRODUCED BY PETER TOSH

ALL SONGS WRITTEN BY PETER TOSH, EXCEPT "NOTHING BUT LOVE" WRITTEN BY FRED HARRIS & ELLA MITCHELL.
RECORDED AND MIXED BY GEOFFREY CHUNG —"NOTHING BUT LOVE" MIXED BY BILLY JACKSON

PETER TOSH: LEAD & BACKING VOCAL, GUITAR, KEYBOARD & PERCUSSIONS
BASS: ROBBIE SHAKESPEARE, DRUMS: SLY DUNBAR, RHYTHM GUITAR: MIKEY CHUNG
LEAD GUITAR: DARRYL THOMPSON, KEYBOARDS: ROBBIE LYN AND KEITH STERLING
PERCUSSIONS: IZIAH "STICKY" THOMPSON AND NOEL "SKULLY" SIMMS, FLUTE: PEE-WEE
TENOR & ALTO: DEAN FRAZER, TROMBONE: NAMBO, TRUMPET: A. BREKENRIDGE & D. MADDEN
HORNS ON: (NOTHING BUT LOVE): LOU MARINI, BARRY ROGERS, LEW SOLOFF & JON FADDIS
BACKING VOCAL: THE TAMLINS, HORNS ARRANGED BY: CLIVE HUNT
LEAD VOCAL ON (NOTHING BUT LOVE): PETER TOSH & GWEN GUTHRIE

PLAIN IMPRESSIONS OF BOTH HANDS

LEFT HAND			RIGHT HAND
Plain impressions of the four fingers taken simultaneously	Plain impressions of THUMBS taken simultaneously		Plain impressions of the four fingers taken simultaneously
	LEFT	RIGHT	

(Fold) Impressions taken by SGT LUCIFER Rank SERGEANT Division # ... Date 13/10/76 (Fold)
Name: Peter Tosh
Offence: Numerous
All the particulars on this form are to be filled in when completed for ...

SPECIAL THANKS TO ALL THE PEOPLE WHO WORKED WITH I ON THE PROJECT. A SPECIAL THANKS TO GWEN GUTHRIE FOR HER PERFORMANCE ON "NOTHING BUT LOVE".

RECORDED AT: DYNAMICS STUDIOS, KINGSTON, JAMAICA: ASSISTANT ENGINEERS: MICHAEL RILEY & NOEL HERN; MIXED AT: A & R STUDIOS, NEW YORK; ASSISTANT ENGINEERS: JAMES NICHOLS & JULIAN McBROWNE; ART DIRECTION & GRAPHICS: NEVILLE GARRICK; PRODUCTION COORDINATION: MEDGE MILLER & THERESA Del POZZO

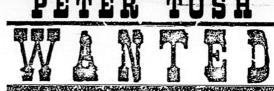

PETER TOSH
WANTED

DREAD & ALIVE

WANTED DREAD & ALIVE
Peter Tosh
Rolling Stone | 1981 | Cover design: Neville Garrick

Like many of the cover artists, Neville Garrick left his distinctive mark on reggae album cover artwork, literally so in the case of Peter Tosh's *Wanted Dread & Alive*. Tosh was legendary for his constant attacks on the Jamaican and British political systems—"shitsems" as he called them. His album covers often reflected his politics, and the back cover of *Dread & Alive* features a mock police report on Tosh, complete with a complaint against him for "numerous" offenses, filled out by a "Sergeant Lucifer." However, the usually fearless Tosh refused to provide his own fingerprints for the cover, concerned that they would be manipulated by police forces already out to get him. Instead, the fingerprints seen on the cover are actually Garrick's own.

Sadly, Tosh could not evade all his enemies for ever. The man who wanted to be dread and alive was shot execution style inside his Kingston home in 1989.

BUNNY WAILER SINGS THE WAILERS
Bunny Wailer
Mango | 1980 | Cover concept: Bunny Wailer | Cover design: Neville Garrick

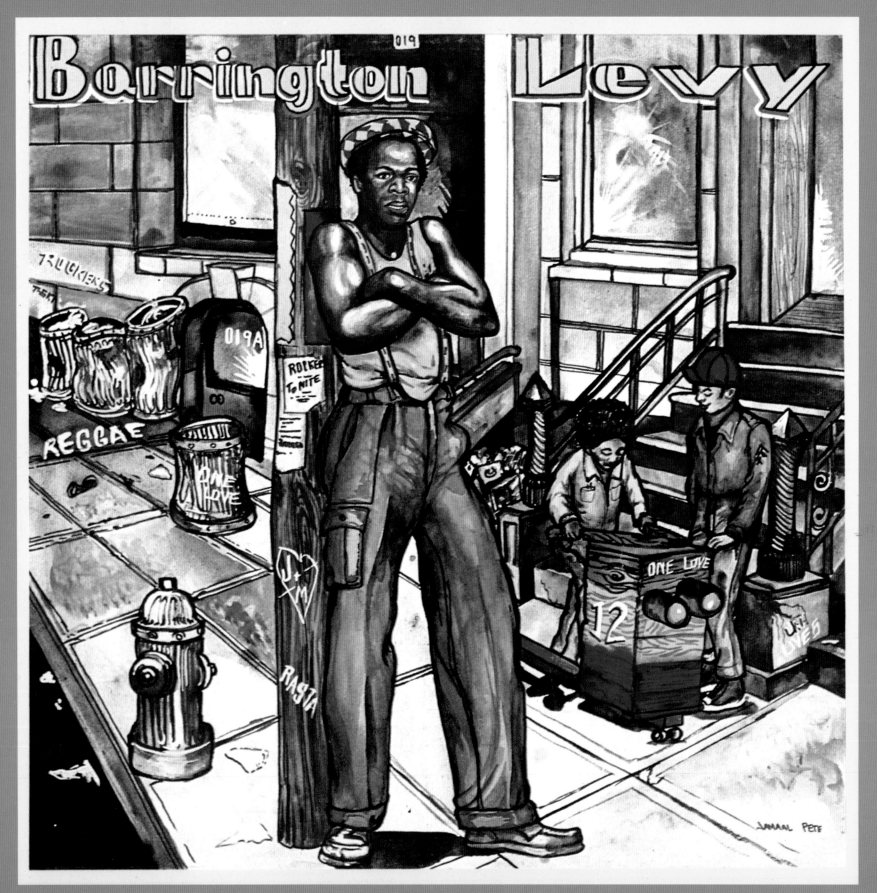

POORMAN STYLE

Barrington Levy

Clocktower | 1983 | Cover illustration: Jamaal Pete

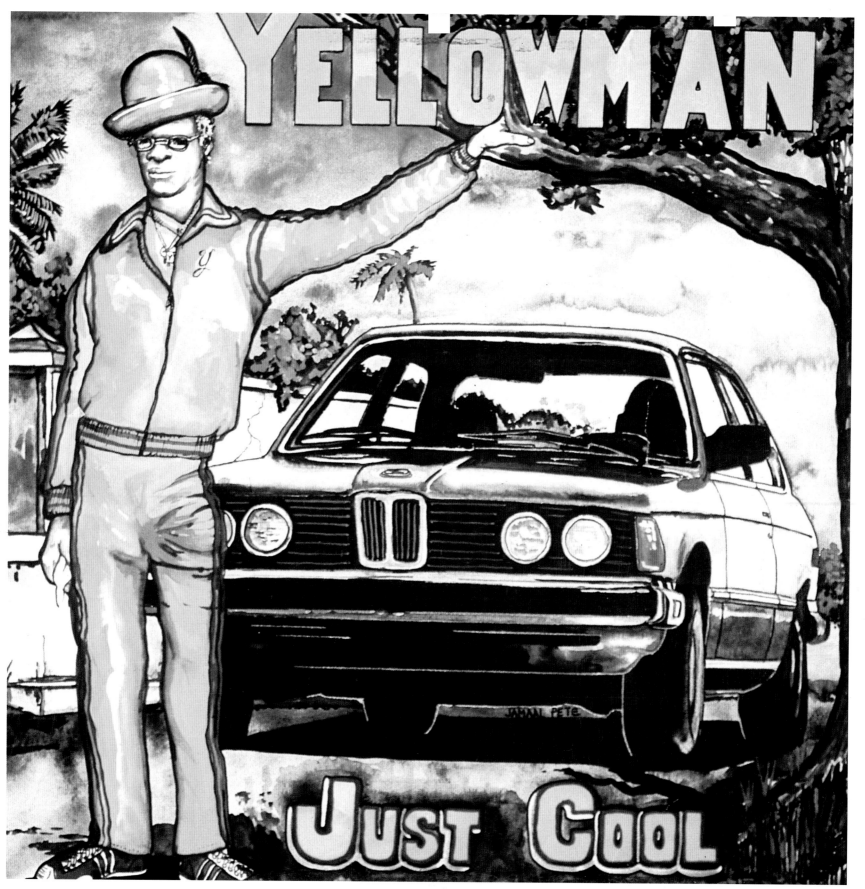

JUST COOL

Yellowman

Guidance | 1982 | Cover illustration: Jamaal Pete

FINAL MISSION

Various artists

Power House | 1984 | Cover design: Wilfred Limonious

LICK SHOT

Michael Palmer

Power House | 1984 | Back cover design: Wilfred Limonious

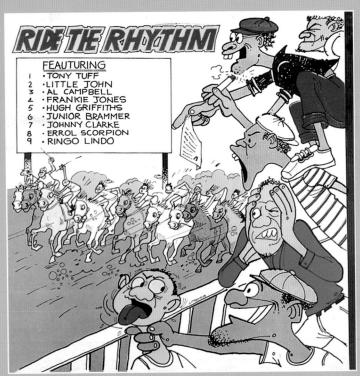

RIDE THE RHYTHM

Various artists

Top Rank | c. 1985 | Cover design: Wilfred Limonious

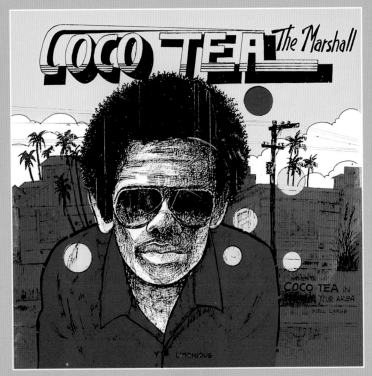

THE MARSHALL

Cocoa Tea

Jammys | 1986 | Cover design: Wilfred Limonious

PUNANY TRAIN

Various artists

Jumbo | c. 1983 | Cover design: Wilfred Limonious

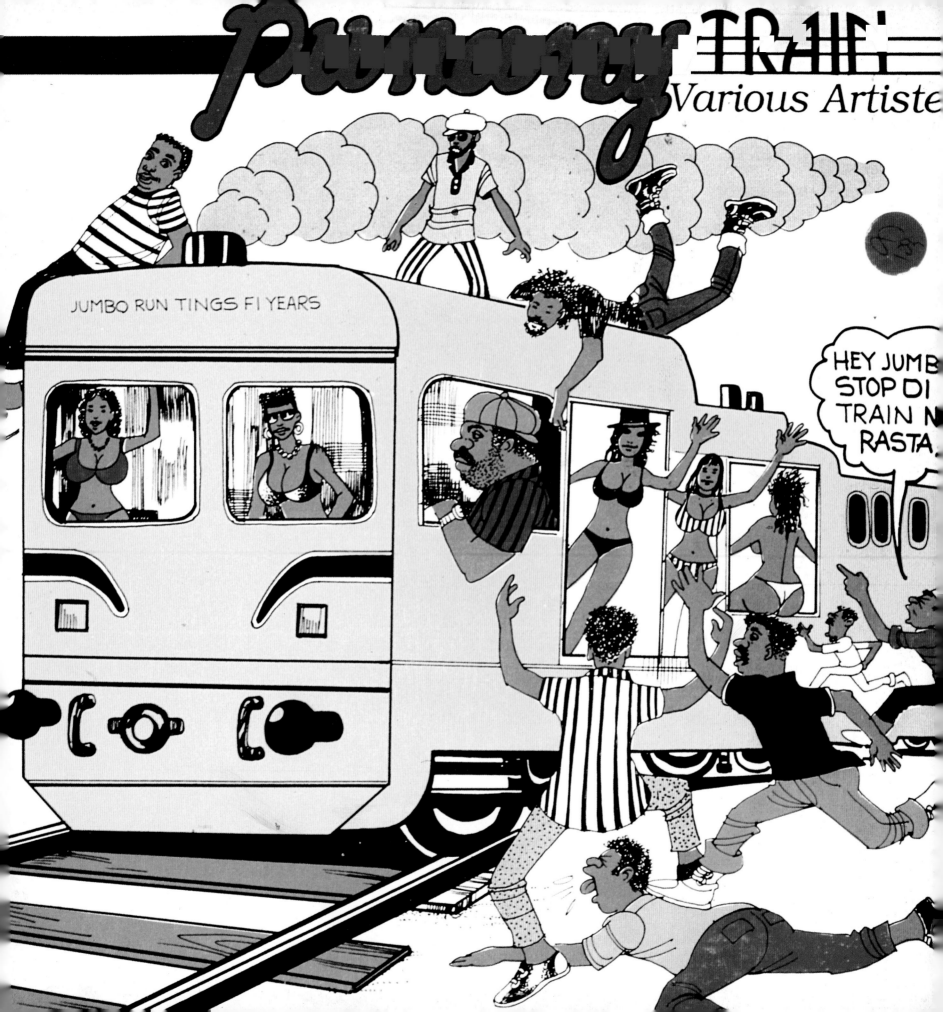

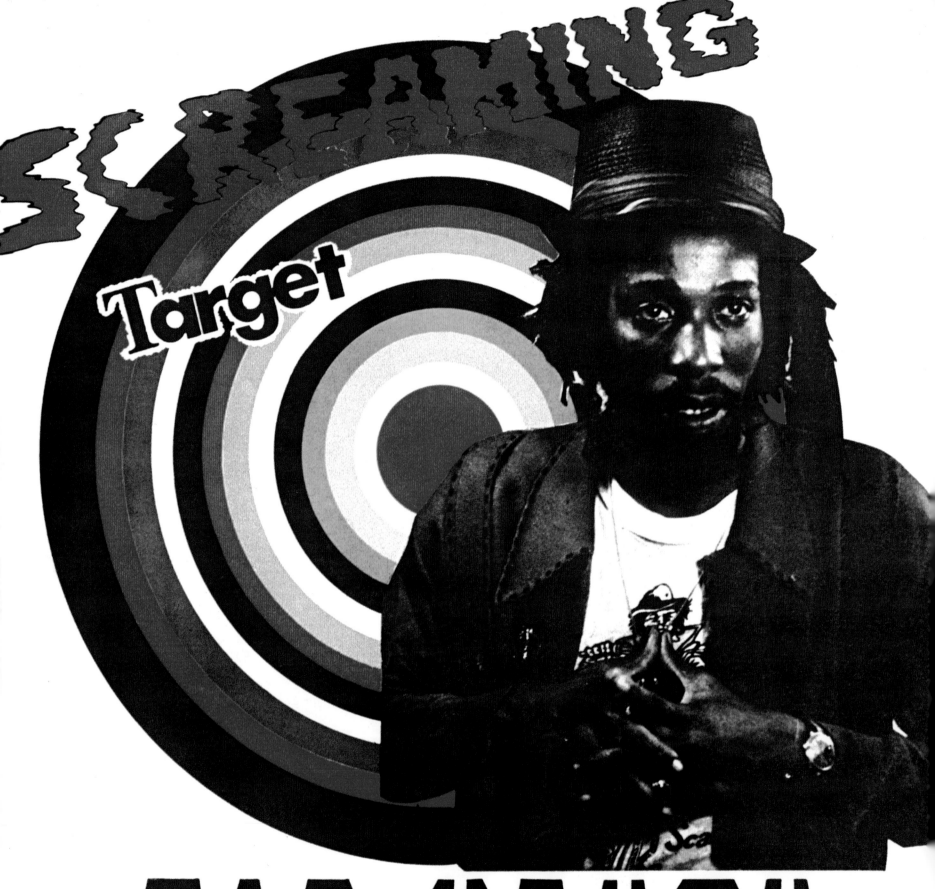

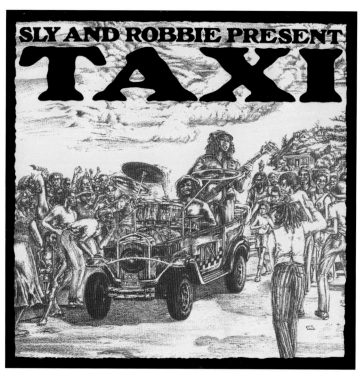

SLY AND ROBBIE PRESENT TAXI

Sly & Robbie

Mango | 1981 | Cover design: Herman Cain

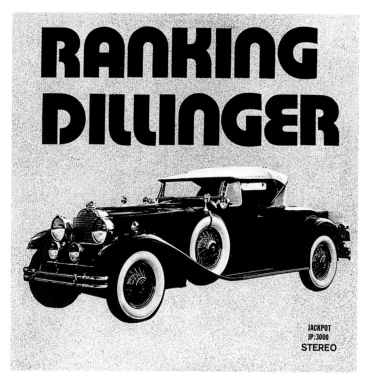

RANKING DILLINGER

Dillinger

Jackpot | *c.* 1978

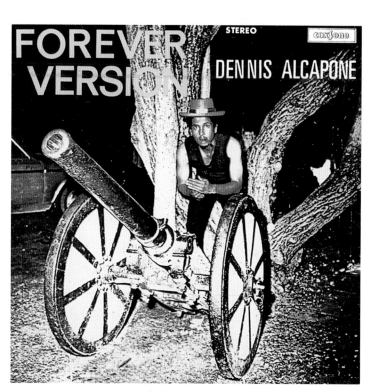

FOREVER VERSION

Dennis Alcapone

Coxsone | 1971

CB200

Dillinger

Mango | 1976 | Cover design: Ripped Baggies

SCREAMING TARGET

Big Youth

Trojan | 1973 | Cover design: Dirk Brown

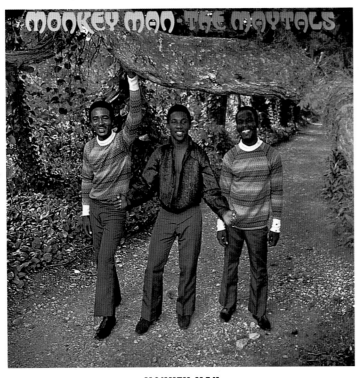

MONKEY MAN

The Maytals

Trojan | 1976 | Cover design: CCS Advertising

FUNKY KINGSTON

Toots & The Maytals

Dragon | 1973

BEST OF BOB MARLEY & THE WAILERS

Bob Marley & The Wailers

Coxsone | 1974

BRUTAL OUT DEH

The Itals

Nighthawk | 1981 | Cover design: Liz Shepard

TELL ME WHAT'S WRONG

The Mighty Diamonds

J&J | 1979 | Cover design: Leslie A. Moore

STRIKE ON

the Mighty Diomondstell me what's wrong

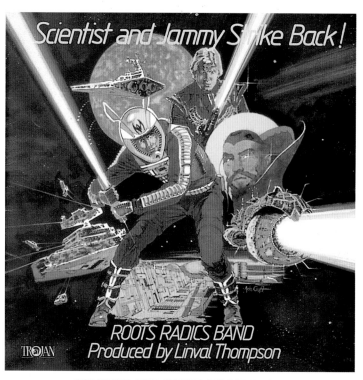

SCIENTIST AND JAMMY STRIKE BACK!

Prince Jammy

Trojan | 1982 | Cover illustration: Ade Cruft

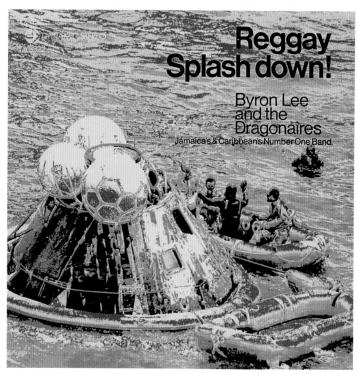

REGGAY SPLASHDOWN!

Byron Lee and the Dragonaires

Dynamic | *c.* 1982 | Cover photo: L.Burnet

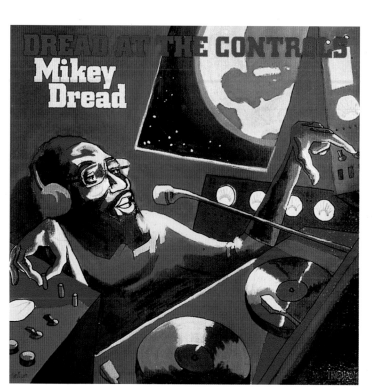

DREAD AT THE CONTROLS

Mikey Dread

Trojan | 1979 | Cover design: Rocking Russian | Cover illustration: Clinton

BADDA DAN DEM

The Lone Ranger

Studio One | 1982 | Cover illustration: Jamaal Pete

PRINCE JAMMY DESTROYS THE INVADERS

Prince Jammy

Greensleeves | 1982 | Cover design: Tony McDermott

1000 VOLTS OF HOLT

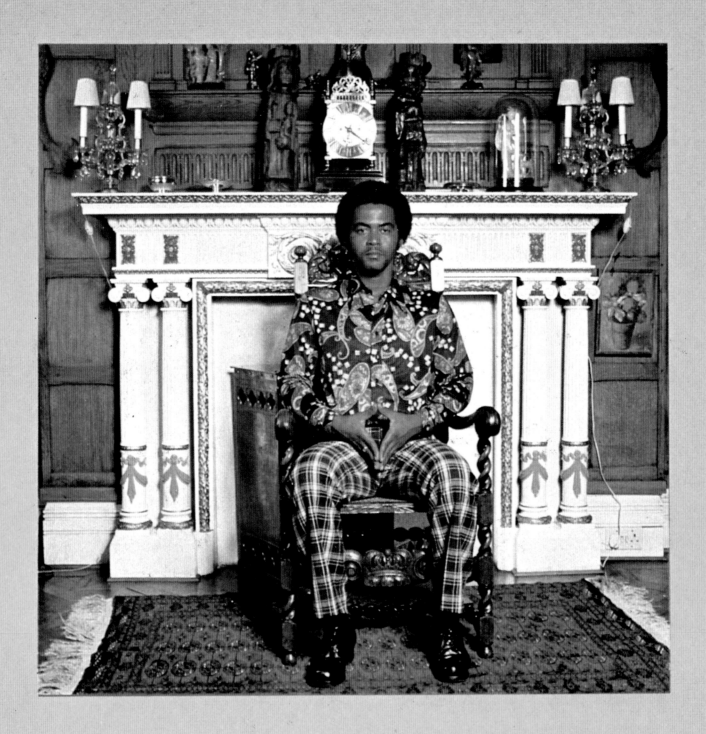

TROJAN

1000 VOLTS OF HOLT

John Holt

Trojan | 1973

REGGAY INTERNATIONAL

Byron Lee And The Dragonaires

Dynamic | 1976 | Cover design: Howard Moo Young

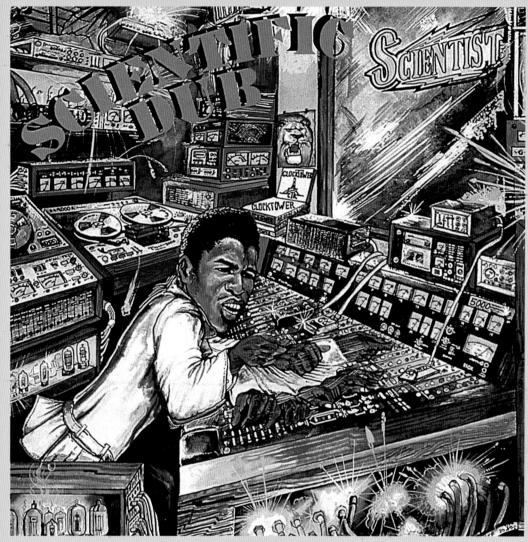

SCIENTIFIC DUB

Scientist

Clocktower | 1980 | Cover illustration: Jamaal Pete

RYDIM

Sugar Minott

Power House | 1985 | Cover design: Wilfred Limonious

MR. MUSIC

Pablove Black

Studio One | *c.* 1978 | Cover design: Glenville Dayle

JUST DENNIS

Dennis Brown

Trojan | 1975 | Cover design: Barry Creasy

BEAUTIFUL WORLD, WONDERFUL PEOPLE

Jimmy Cliff

A&M | 1970

Detail from **AQUARIUS DUB**

Herman Chin-Loy

Aquarius | 1973

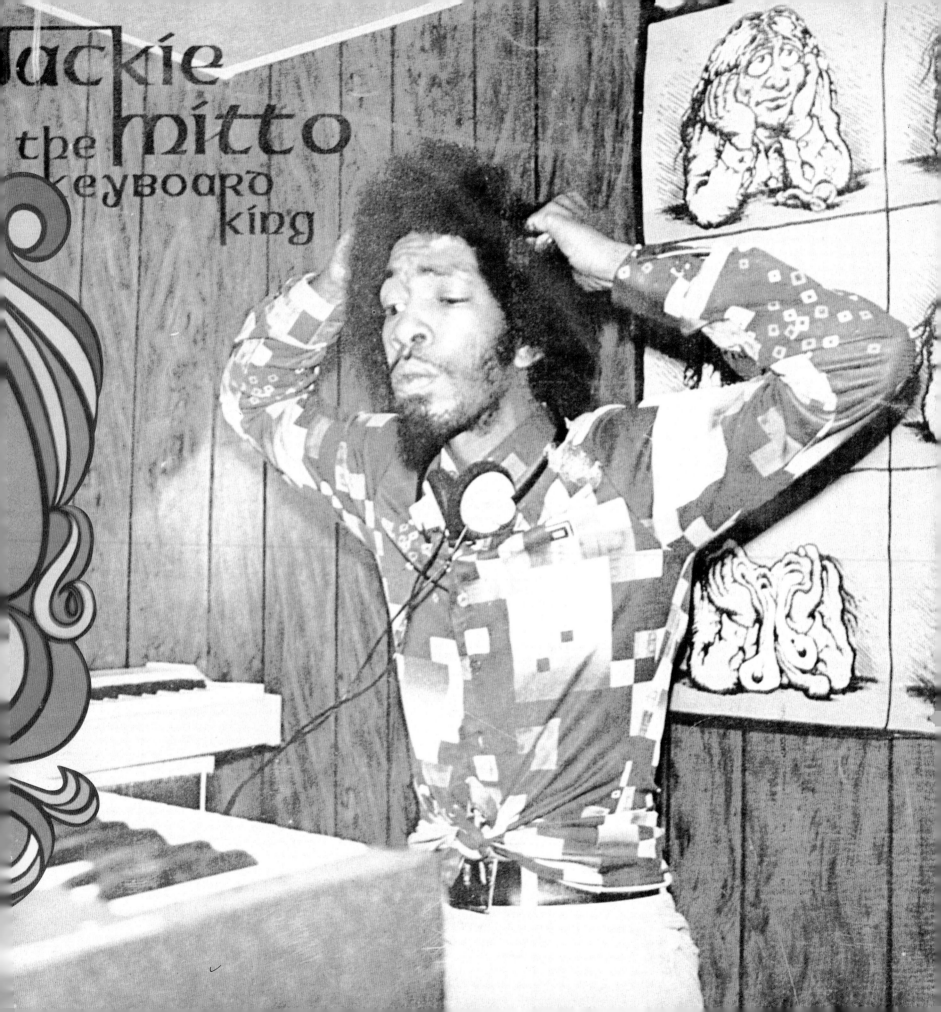

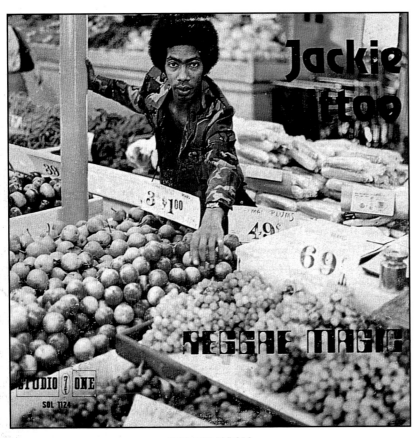

REGGAE MAGIC

Jackie Mittoo

Studio One | 1972 | Cover photography: Murray Wilson

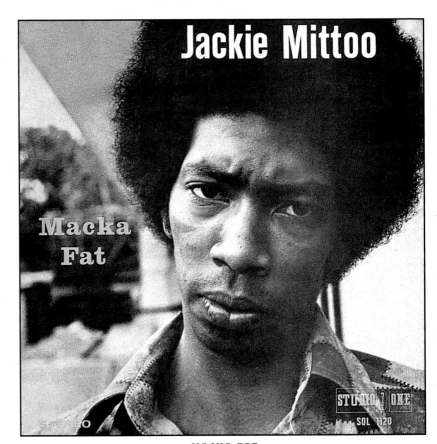

MACKA FAT

Jackie Mittoo

Studio One | 1970

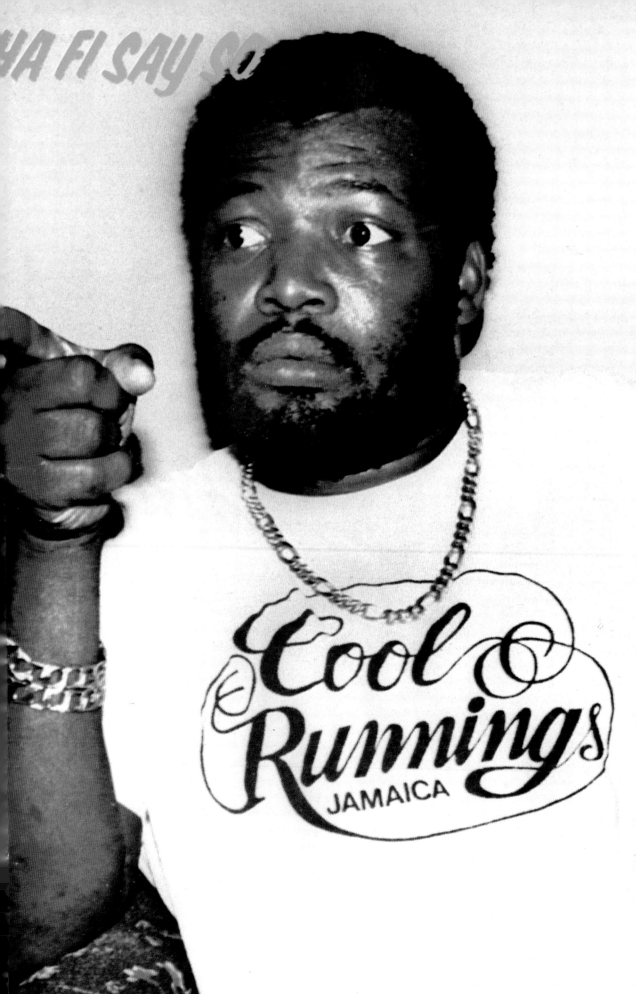

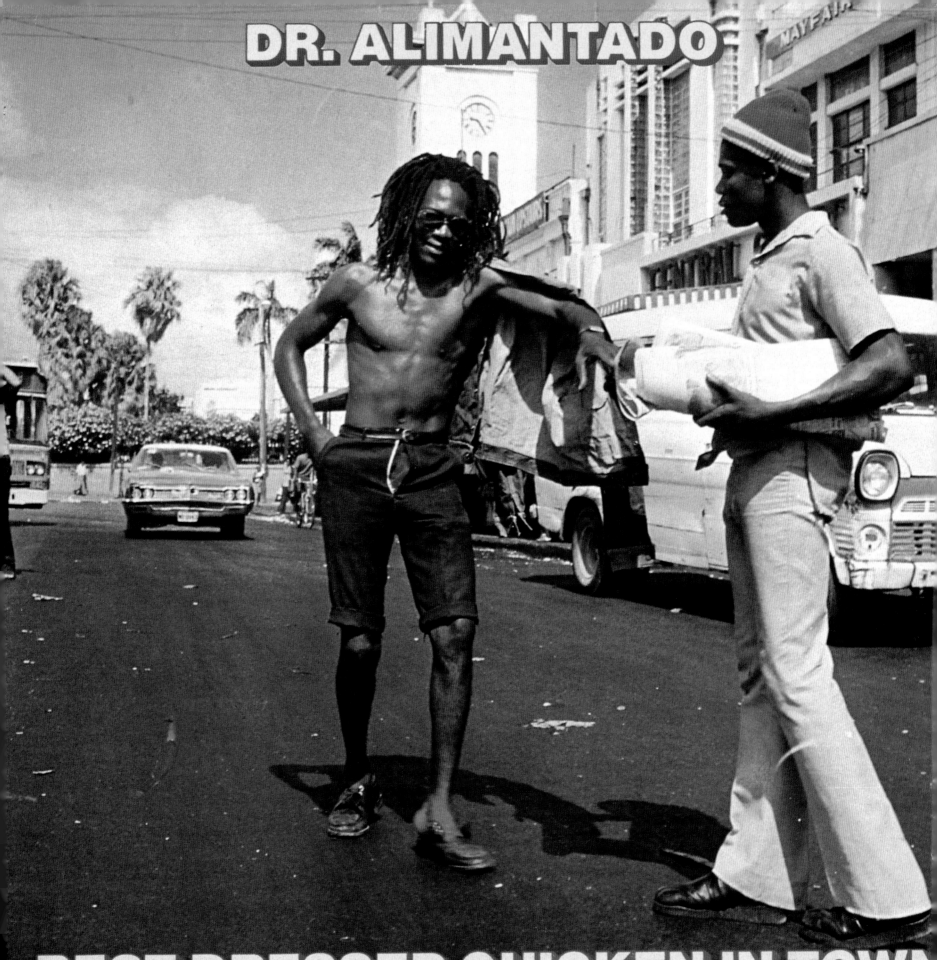

DR. ALIMANTADO

BEST DRESSED CHICKEN IN TOWN

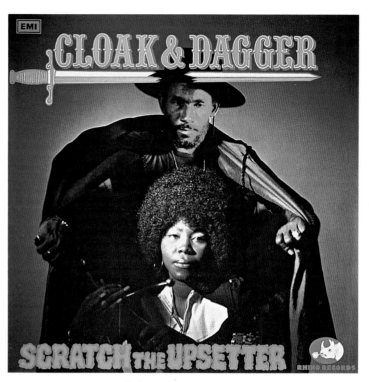

CLOAK AND DAGGER

Scratch The Upsetter

EMI | 1972

RETURN OF THE WAX

Lee Perry and The Upsetters

Justice League | reissue | *c.* 1998

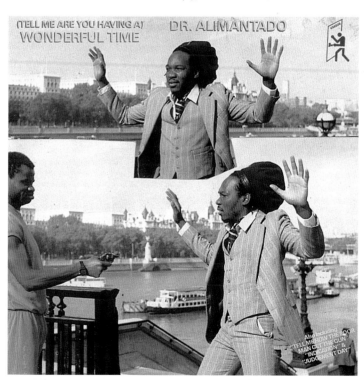

WONDERFUL TIME

Dr. Alimantado

K Records | *c.* 1987 | Cover design: R. Tado, Tony Nero

RETURN OF THE SUPER APE

Upsetters

K Records | 1978 | Cover illustration: Lloyd Robinson

BEST DRESSED CHICKEN IN TOWN

Dr. Alimantado

Greensleeves | 1978 | Cover photo: D.K. James

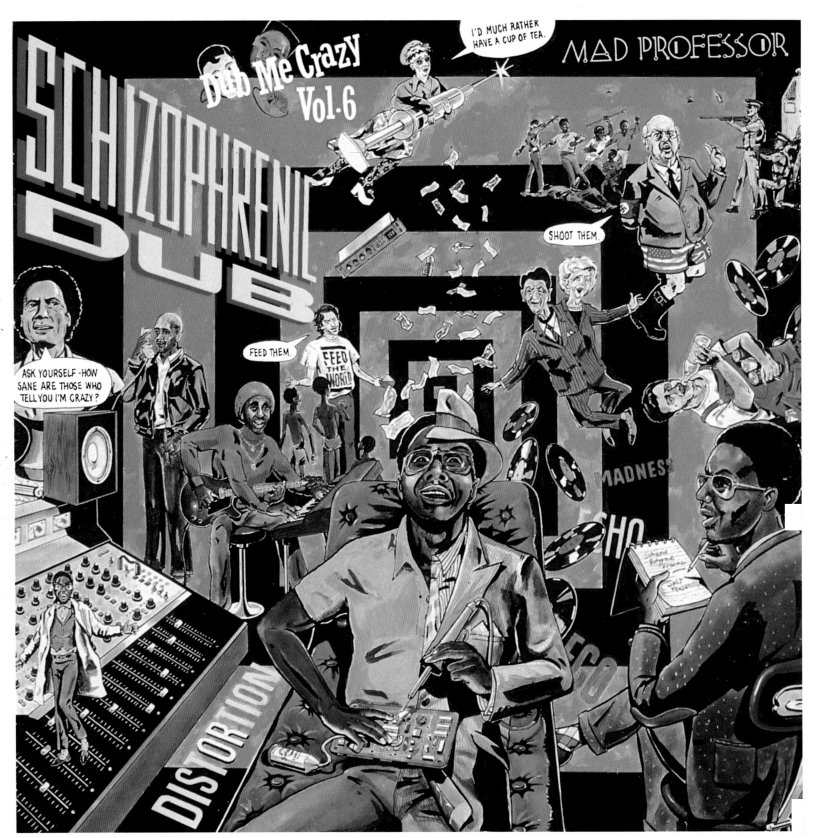

SCHIZOPHRENIC DUB

Mad Professor

Ariwa | 1986 | Cover design: Tony McDermott

HEAVYWEIGHT DUB CHAMPION

Scientist

Greensleeves | 1980 | Cover design: Tony McDermott

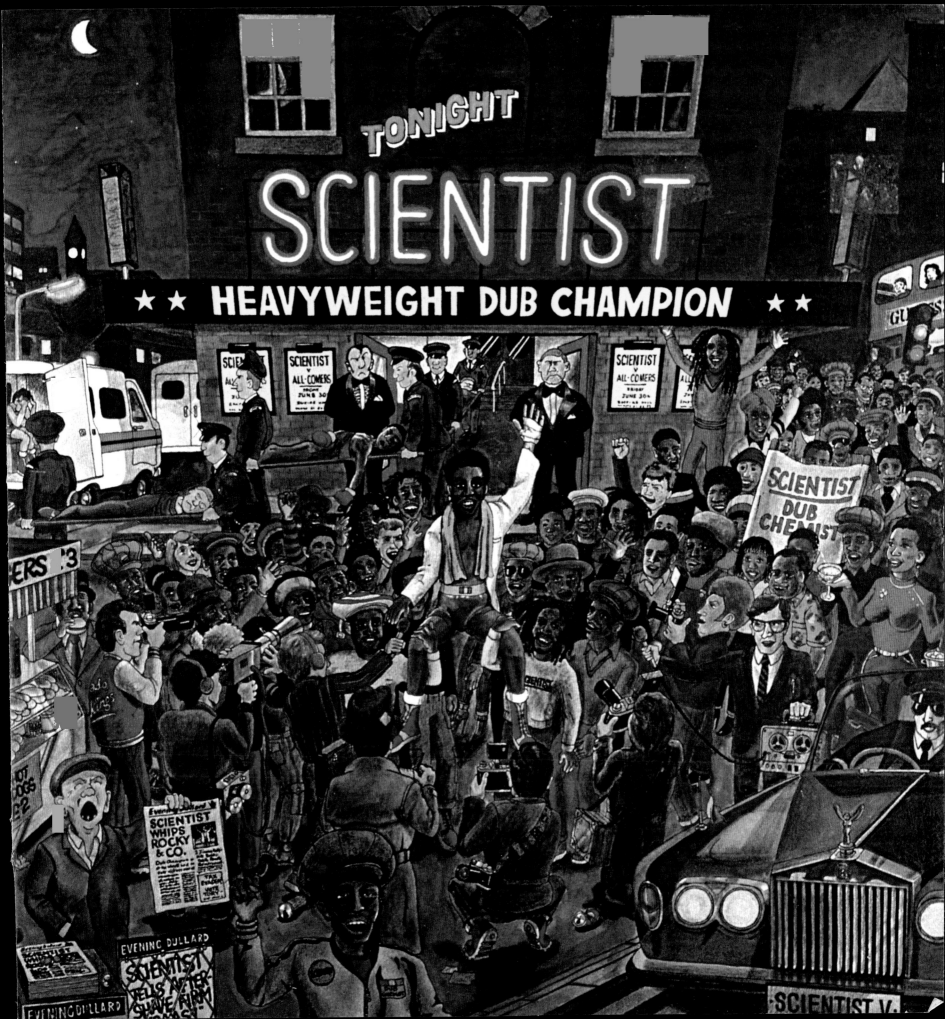

As any avid record collector can tell you, books aren't the only things that shouldn't be judged by their covers. More than one collector has been lured into buying an album on the strength of its sleeve, only to be sorely disappointed on hearing the music. This discography grew out of the assumption that, after enjoying looking at this book, most people will also be interested to hear the music on the albums featured. Yet, since the LPs in this book have been selected for their outstanding covers, the question naturally arises: which of them are worth not only looking at, but also listening to? Thankfully, the answer is: a good many of them. But it should be noted that this book focuses on a very specialized aspect of reggae—its album cover artwork—and this discography only recommends albums within this spectrum. Of course there are countless reggae albums whose music is a must, but whose covers did not make it into this book.

Unlike the main section of the book, the discography is presented chronologically, with albums grouped according to ska, rocksteady, early reggae, roots, dub, and dancehall. Each section begins with an alphabetical list of recommended LPs from the period, as well as thumbnail descriptions of the best albums. The list also includes each LP's original release date, label, and catalogue number where applicable. In reggae, it was not unusual for an LP to be released on separate labels in Jamaica (JA), the UK, and the USA, often with different covers. So while these LP catalogue numbers might not be uniform for every edition of an LP, they do represent the specific covers photographed for this book.

CD catalogue numbers are given for those albums that have also been released on compact disc. Although all covers in the book have been photographed from LPs, many of the rarer albums might prove difficult (and costly) to obtain on vinyl, making CDs a more realistic alternative for listening to the music.

Trying to navigate reggae's labyrinth of release dates, labels, and catalogue numbers is an adventure that has confounded more knowledgeable experts than myself. Hopefully the information I have gathered will prove useful not only for hardcore reggae fans, but also for those just beginning to explore the music.

SKA AND ROCKSTEADY

All Star Top Hits, Various artists, 1961
Coxsone (JA)
Come Rock With Me In Jamaica, Various artists, c. 1969
Treasure Isle, LP-101 (JA)
Fly, Flying Ska, Prince Buster, 1964
Blue Beat, BBLP-803 (UK)
Hot Shot, Soul Brothers, 1967
Coxsone, SOLP-112 (JA)
Jamaican Skarama, Various artists, 1965
Kentone, FSR-101LP (JA)
Jump Jamaica Way, Various artists, 1963
ND Records, JBL-1111 (JA)
Mr. Rock Steady, Ken Boothe, 1968
Studio One, SOLP-1112 (US)
CD: Studio One, SOCD-1112 (UK)
Never Grow Old, The Maytals, c. 1966
Coxsone, JBL-1113 (UK)
Presenting Jamaica All Stars Vol. 1,
Various artists, 1966
Studio One, SO-103 (JA)
Reggae In The Grass, Various artists, 1968
Studio One, SOL-9007 (UK)
Rock-steady Explosion, Byron Lee &
The Dragonaires, c. 1968
Dynamic Sounds, Soul BLP-010 (JA)
Ska-Au-Go-Go, Various artists, 1967
Studio One, SO-111 (JA)
Ska Authentic, The Skatalites, 1967
LP: Studio One, SOL-9006 (JA)
CD: Studio One, SOCD-9006 (US)
Ska-Lip-Soul, Prince Buster, c. 1966
Blue Beat, BBLP-805 (UK)
Ska Mania, Carlos Malcolm and His Afro-
Jamaican Rhythms, c. 1965
Up-Beat (JA)
The Wailing Wailers, The Wailers, c. 1965
LP: Studio One, SLOP-1001 (JA)
CD: Studio One, SOCD-1001 (JA)*
*see Roots Reggae

Many of the best ska and rocksteady albums in this book were released on Coxsone Dodd's Studio One label, including the compilations *Jump Jamaica Way*, *All Star Top Hits*, *Presenting Jamaica All Stars Vol. 1* and The Soul Brothers' *Hot Shot*. *All Star Top Hits* and *Jump Jamaica Way* are particularly worthwhile, as they vividly reveal the influence of American R & B on embryonic ska; *Jump Jamaica Way* contains vocals by The Maytals as well as instrumental tracks from Tommy McCook and Don Drummond.

The mid-'60s prime of ska innovator Prince Buster is well represented on two rare LPs, *Ska-Lip-Soul* and *Fly, Flying Ska*. For ska compilations there is the hard-to-find *Jamaican Skarama*, as well as *Ska-Au-Go-Go*, highlighted by legendary ska saxophonist Roland Alphonso.

For ska instrumentals, the Skatalites' *Ska Authentic* stands alone—the most important album from Jamaica's most important band. Many members of the Skatalites back up The Maytals on *Never Grow Old*, which assembles much of this vocal group's output from Studio One. Carlos Malcolm's *Skamania* is another fine example of the genre.

Check for two more Studio One rocksteady classics, Ken Boothe's *Mr. Rock Steady*, with several of the impassioned vocalist's early hits, and *Reggae in The Grass*, with cuts by such luminaries as Bob Andy and Delroy Wilson.

Despite a commercially successful career spanning four decades, Byron Lee and The Dragonaires have often been dismissed for producing watered-down reggae. *Rock-steady Explosion*, more relevant than most of Lee's later output, is at least a serviceable rocksteady collection.

EARLY REGGAE

A Dream, Max Romeo, 1969
Pama (UK)
Beat Down Babylon, Junior Byles, 1973
LP: Trojan, TRL-52 (UK)
CD: on *Beat Down Babylon: The Upsetter Years*, Trojan, TRC-253 (UK)
Better Must Come, Delroy Wilson, 1972
Dynamic, DY-3324 (JA)
Clint Eastwood, The Upsetters, 1969
Pama, PSP-1014 (UK)
Forever Version, Dennis Alcapone, 1971
LP: Studio One, CSL-8025 (JA)
CD: Heartbeat, HB-3505 (US)
Freedom, Clancy Eccles, 1969
Trojan, TTL-22 (UK)
Funky Kingston, Toots & The Maytals, 1973
LP: Dragon, DRLS-5002 (UK)
CD: Trojan, CDTRL-201 (UK)
The Good, The Bad & The Upsetters,
The Upsetters, 1970
LP: Trojan, TBL-119 (UK)
CD: Lagoon, LGCD 1083 (France)
The Harder They Come, Soundtrack,
Various artists, 1972
LP: Island, ILPS-9202 (UK)
CD: Mango, PGDCD-539202 (US);
Mango RRCD-1 (UK)
Kung Fu Meets The Dragon, The Mighty Upsetter, c. 1975
LP: DIP, LP-6006, (UK)
CD: Justice League, JLCD-5000 (UK)
Macka Fat, Jackie Mittoo, 1970
Studio One, SOL-1120 (JA)
Many Moods of The Upsetters,
The Upsetters, 1970
Pama, SECO-24 (UK)
Monkey Man, The Maytals, 1976
Trojan, TBL-107 (UK)
Reggae Magic, Jackie Mittoo, 1972
Studio One, SOL-1124 (Canada)
Screaming Target, Big Youth, 1973
LP: Trojan, TRLS-61 (UK)

CD: Trojan, TRCD-061 (UK)
Tighten Up Vol. 1, Various artists, 1969
LP: Trojan, TTL-1 (UK)
CD: Trojan, CDTRL-306 (UK)
Tighten Up Vol. 2, Various artists, 1969
LP: Trojan, TTL-7 (UK)
CD: Trojan, CDTRL-306 (UK)

The term "early reggae" is often used to describe reggae's transition period during the late '60s and early '70s, when the music was beginning to outgrow its ska and rocksteady roots, but had not yet fully refined the thick bass and slowed tempo that would become its trademark.

The instrumental LPs from this period were dominated by The Upsetters, Lee "Scratch" Perry's seminal session band. Important Perry and Upsetters releases include *Clint Eastwood*, *Kung Fu Meets The Dragon*, *Many Moods of the Upsetters*, and *The Good, The Bad & The Upsetters*. And check for Skatalite graduate Jackie Mittoo's instrumental LPs *Macka Fat* and *Reggae Magic*.

Other noteworthy LPs from early reggae include Delroy Wilson's *Better Must Come*, Clancy Eccles' superlative *Freedom*, and Junior Byles' *Beat Down Babylon*, which foreshadowed reggae's impending roots explosion. Two important, if not crucial Maytals albums are *Monkey Man* and *Funky Kingston*. Before becoming a fiery Rasta evangelist in the mid-'70s, Max Romeo was notorious for the type of sexually suggestive fare found on 1969's *A Dream*. Several early DJ records were released during this era, including undisputed classics like Big Youth's *Screaming Target* and Dennis Alcapone's *Forever Version*.

Many of the vintage tracks from early reggae are found on compilations. The *Tighten Up* series are useful samplers from the period, *Volumes 1, 2* and *3* especially. The finest compilation from this era is unquestionably the soundtrack for *The Harder They Come*. This album was the one that introduced many rock fans to reggae and it's easy to see why. All the album's tracks are of the highest quality and totally accessible.

ROOTS REGGAE

Africa Must Be Free By 1983, Hugh Mundell, 1978
LP: Message (US)
CD: with *Africa Dub*, Greensleeves, GRELCD-504 (UK)
African Musium All Star, Various artists, 1983
LP: African Museum (JA)
CD: *Gregory Isaacs & Friends Top Ten*, Heartbeat, HB-19 (US)

Are We A Warrior, Ijahman Levi, 1979
 LP: Island, MLPS-9557 (UK)
 CD: Mango, RRCD-25 (UK)
Babylon By Bus, Bob Marley & The Wailers, 1978
 LP: Island, ISLD-11 1298 (UK)
 CD: Tuff Gong, TGCD-197 (US);
 Island, TGDCD-1 (UK)
Barnabas in Collins Wood, Lone Ranger, 1979
 GG's, GG-021 (JA)
Best Dressed Chicken In Town,
 Dr. Alimantado, 1978
 LP: Greensleeves, GREL-1 (UK)
 CD: Greensleeves, GRELCD-001 (UK)
The Best of The Wailers, Bob Marley & The Wailers, 1974
 Coxsone (JA)
Blackheart Man, Bunny Wailer, 1976
 LP: Solomonic, LP-18334 (JA)
 CD: Mango, PGDCD-539415 (US);
 Mango RRCD-6 (UK)
Black Star Liner, Fred Locks, 1976
 LP: Vulcan, VULA-502 (UK)
 CD: VP, VPCD-2037 (US)
Bobby Bobylon, Freddie McGregor, 1980
 LP: Studio One, SLOP-1039 (US)
 CD: Heartbeat, HB-3502 (US)
Brutal Out Deh, The Itals, 1981
 LP: Nighthawk, NH-303 (US)
 CD: Nighthawk, NHCD-303 (US)
Burnin', Bob Marley & The Wailers, 1973
 LP: Island, ILPS-9256 (UK)
 CD: Tuff Gong, TGCD 197 (US);
 Island, TGLCD-2 (UK)
Catch A Fire, Bob Marley & The Wailers, 1974
 LP: Tuff Gong/Island, ILPS-9241B (JA)
 CD: Tuff Gong, TGCD-201 (US);
 Island, TGLCD-1 (UK)
Confrontation, Bob Marley & The Wailers, 1983
 LP: Island, LP-90085-1 (US)
 CD: Tuff Gong, TGCD-207 (US);
 Island, TGLCD-10 (UK)
Conquering Lion, Yabby-You & The Prophets, 1976
 Micron (JA)
DJ Round Up, Various artists, 1976
 Trojan, TRLS-135 (UK)
Dread In A Babylon, U-Roy, 1975
 LP: Virgin, V-2048 (UK)
 CD: Virgin Front Line, CARCD-1683 (UK)
Dread Locks Dread, Big Youth, 1975
 LP: Klik, KLP-9001 (UK)
 CD: Virgin Front Line, CARCD-1682 (UK)
Earth Crisis, Steel Pulse, 1984
 LP: Elektra, 60315-1 (US)
 CD: Elektra, WEACD-60315 (US)
Exodus, Bob Marley & The Wailers, 1977
 LP: Island, 90034-1 (US)
 CD: Tuff Gong, TGCD-208 (US);
 Island, TGLCD-6 (UK)

Hail H.I.M., Burning Spear, 1980
 LP: Burning Spear, LP-16226 (JA)
 CD: Heartbeat, HB-145 (US)
Haile I Hymn, Ijahman Levi, 1978
 LP: Island (UK)
 CD: Mango, PGDCD-539521 (US);
 Mango, RRCD-35 (UK)
Heart of The Congos, The Congos, 1977
 LP: Black Art (JA)
 CD: Blood & Fire, BAFCD-009 (UK)
Hulet, Aswad, 1978
 LP: Grove Music, GMLP-6 (UK)
 CD: Mango, PGDCD-539868 (US)
Jerusalem, Alpha Blondy, 1986
 LP: Shanachie, 43062 (US)
 CD: Shanachie, SHCD-43054 (US)
Just Dennis, Dennis Brown, 1975
 Trojan, TRLS-107 (UK)
Kaya, Bob Marley & The Wailers, 1978
 LP: Island, ILPS-9517, UK
 CD: Tuff Gong, TGCD-209 (US);
 Island, TGLCD-7 (UK)
Legalize It, Peter Tosh, 1976
 LP: CBS, PL-34253 (UK)
 CD: Columbia, CKCD 34253 (US)
Life Of Contradiction, Joe Higgs, 1975
 LP: Grounation, GROL-508 (UK)
 CD: Grounation, GRCD-508 (UK);
 Lagoon, LGCD-1010 (France)
Lion Rock, Culture, 1981
 LP: Sonic Sounds (JA)
 CD: Heartbeat, HB-12 (US)
Love Thy Neighbour, Ras Michael & The Sons of Negus, 1984
 LP: Live & Learn, LLLP-001 (US)
 CD: Live & Learn, LLCD-001, (US);
 Greensleeves, LLCD-001 (UK)
Marcus Garvey, Burning Spear, 1975
 LP: Island, ILPS-9377 (UK)
 CD: with *Garvey's Ghost*, Mango,
 PGDCD-539377 (US);
 Mango, RRCD-20 (UK)
Mellow Mood, Judy Mowatt, 1975
 Tuff Gong, #79 (JA)
Mr. Music, Pablove Black, c. 1978
 Studio One, SOL-132 (JA)
Natty Cultural Dread, Big Youth, 1976
 Trojan, TRLS-123 (UK)
Natty Dread, Bob Marley & The Wailers, 1975
 LP: Island, ILPS-9281 (UK)
 CD: Tuff Gong, TGCD-204 (US);
 Island, TGLCD-3 (UK)
96° In The Shade, Third World, 1977
 LP: Island (UK)
 CD: Mango, PGDCD-539830 (US);
 Mango, RRCD-16 (UK)
No Nuclear War, Peter Tosh, 1987
 Elektra, ELT-46700 (US)
Nyahbinghi, Ras Michael & The Sons of Negus, 1974
 LP: Trojan, TRL-113 (UK)
 CD: Trojan, CDTRL-400 (UK)

Only A Woman, Judy Mowatt, 1982
 LP: Shanachie, 43007 (US)
 CD: Shanachie, SHCD-43007 (US)
Protest, Bunny Wailer, 1977
 LP: Mango, MLPS-9512-B (US)
 CD: Mango, PGDCD-539512 (US)
Rastafari, Ras Michael & The Sons of Negus, 1975
 LP: Vulcan, VULP-005 (UK)
 CD: Greensleeves, GRELCD-153 (UK)
Rastaman Vibration, Bob Marley & The Wailers, 1976
 LP: Island, 90033-1 (US)
 CD: Tuff Gong, TGCD-205 (US);
 Island, TGLCD-5 (UK)
Righteous Are The Conqueror, Michael Prophet, 1980
 LP: Greensleeves, GREL-18 (UK)
 CD: with *Gunman*, Greensleeves, GRELCD-08 (UK)
Rocking Time, Burning Spear, 1976
 LP: Studio One/Buddah, SO-1103 (US)
 CD: Studio One, SOCD-01123 (US)
Sinsemilla, Black Uhuru, 1980
 LP: Mango (US)
 CD: Mango, PGDCD-539593 (US);
 Mango, RRCD-12 (UK)
Soul Rebels, Bob Marley & The Wailers, 1970
 LP: Trojan, TBL-126 (UK)
 CD: Action Replay, CDAR-1013 (UK)
Stand Up To Your Judgment, The Mighty Diamonds, 1978
 LP: Hitbound, JJLP-020A (US)
 CD: Hitbound, JJCD-020A (US)
State Of Emergency, Joe Gibbs & The Professionals, c. 1983
 LP: Rocky One, RGLP-037 (JA)
 CD: Rocky One, RGCD-037 (US)
Survival, Bob Marley & The Wailers, 1979
 LP: Island, ILPS-9542 (US)
 CD: Tuff Gong, TGCD-202 (US);
 Island, TGLCD-8 (UK)
Sweet Bitter Love, Marcia Griffiths, 1974
 LP: Trojan, TRLS-94 (UK)
 CD: Trojan, CDTRL-325 (UK)
Tales Of Mozambique, Ras Michael & The Sons of Negus, 1975
 LP: Dynamic, DY-3358 (JA)
 CD: Crocodisc, CCCD-701 (France)
Tell Me What's Wrong, The Mighty Diamonds, 1979
 LP: Hitbound, JJ-021 (US)
 CD: VP, JJ-021 (US)
Tribute to the Martyrs, Steel Pulse, 1979
 LP: Mango (US)
 CD: Mango, RRCD-17 (UK)
Uprising, Bob Marley & The Wailers, 1980
 LP: Island, ILPS-9596 (US)
 CD: Tuff Gong, TGCD-211 (US);
 Island, TGLCD-9 (UK)
Who Feels It Knows It, Rita Marley, 1981
 LP: Shanachie, 43003 (US)
 CD: Shanachie, SHCD-43003 (US)

"Roots" has become a blanket term employed to describe the heavy, culturally concerned style of reggae which flourished during the '70s. The roots explosion was exemplified by albums like Fred Locks' *Black Star Liner*, Yabby You and The Prophets' *Conquering Lion*, and Ijahman Levi's *Haile I Hymn* and *Are We A Warrior*. These masterpieces exemplified the heartfelt expressions of reggae's spiritual connection with Rastafarianism and commitment to social commentary.

This book also includes a handful of important LPs that emphasize traditional Rastafarian Nyahbinghi drumming. Ras Michael and The Sons of Negus' *Rastafari*, *Nyahbinghi* and *Love Thy Neighbour* are fine examples, as is Rastafarian elder Count Ossie's *Tales of Mozambique*.

An almost criminally underexposed roots LP is Hugh Mundell's *Africa Must Be Free By 1983*, which features Mundell's exquisite tenor over Augustus Pablo's rhythms, with mesmerizing results. Other classic vocal performances are found on the veteran singer Joe Higgs' *Life Of Contradiction* (he taught the young Wailers how to sing harmonies in his yard) and on Freddie McGregor's *Bobby Bobylon*. Two instrumental albums are also recommended: Pablove Black's *Mr. Music* and Joe Gibbs and The Professionals' *State Of Emergency*.

Fans of roots harmonies should look for The Congos' *Heart of The Congos*. The album represents one of producer Lee Perry's transcendent moments, and should be sought out at all costs. Other important LPs in this vein include The Mighty Diamonds' *Stand Up To Your Judgment* and *Tell Me What's Wrong*, Culture's *Lion Rock*, and the Itals' *Brutal Out Deh*. *African Musium All Star* is an excellent sampler of acts from Gregory Isaacs' African Museum label. Despite the presence of several Isaacs' standards, including "Top Ten," it is The Viceroys who steal the show with their sublime harmonies on "Brethren And Sistren."

The roots period also marked the rise of several reggae artists to international prominence. Foremost among these, of course, was Bob Marley. Marley's ska roots are captured on *The Wailing Wailers* and *The Best Of The Wailers*. *The Best of The Wailers* is the stronger of the two, though *The Wailing Wailers* offers Marley fans a revealing, if raw, journey through the group's early sounds. *Soul Rebels* showcases Marley's early '70s work with Lee Perry, a particularly creative period for both superstars. The best collection from their collaboration (though not featured in this book) is *African Herbsman*, one of Marley's most durable sets from any era.

It is almost pointless to try to rate Marley's albums with Island, since they have assumed an importance that transcends musical taste. The love these albums receive throughout the world is so strong that obviously they should all be heard. Yet distinctions do exist. *Burnin'* and *Natty Dread* are probably Marley's most cohesive albums with Island, while *Survival* must be lauded for its ambitious political agenda. *Uprising,* Marley's last album before his death in 1981, still holds up well, while the posthumously released *Confrontation,* apart from a few outstanding songs, is not as strong.

As for former Wailers Bunny Wailer (Bunny Livingston) and Peter Tosh, each produced several exceptional roots albums. The strongest is Bunny Wailer's debut LP, *Blackheart Man,* as essential as any of Marley's solo work. Wailer's 1977 release *Protest,* though initially not as highly regarded, has aged well. Peter Tosh's *Legalize It* was his most successful solo LP, highlighted by the title track's timeless homage to ganja. *No Nuclear War,* released towards the end of the singer's too short career, features Tosh railing with controlled yet contagious passion against nuclear war, apartheid, and those who would take his ganja away.

Also from the Wailer family, check for the solo work of Marley's backing singers, the I-Three. Marcia Griffiths, Rita Marley, and Judy Mowatt were all established performers before linking up with Bob Marley; their considerable talents are showcased respectively on Griffiths' *Sweet Bitter Love,* Marley's *Who Feels It Knows It,* and Mowatt's *Mellow Mood* and *Only A Woman.* Another woman who made a lasting impact on roots reggae was Puma Jones, one-third of the trio Black Uhuru who released a string of socially conscious LPs during the late '70s and early '80s, and for a time seemed poised to fill the international vacuum created by Bob Marley's death. Though a fluctuating lineup and changing tastes would ultimately derail the group, they were able to release several ground-breaking LPs, including *Sinsemilla* in 1980.

Another politically charged reggae superstar was Winston Rodney, aka Burning Spear, who has several exceptional albums featured in this book. His second LP, *Rocking Time,* is a must, as are subsequent classic releases *Marcus Garvey* and *Hail H.I.M.* Dennis Brown is still one of reggae's most popular and prolific recording artists; his LP *Just Dennis* finds the "Crown Prince" of reggae enjoying one of his stronger collaborations with producer Winston "Niney" Holmes.

As for the DJs, *Natty Cultural Dread* and *Dread Locks Dread* represent some of Big Youth's better output. And U-Roy's *Dread In A Babylon* is worth a listen, despite the fact that its cover is more memorable than its music. One DJ album that can claim both an incredible cover and music is Dr. Alimantado's *Best Dressed Chicken In Town.* Alimantado might never have reached such heights again, but for this album at least he was magnificent. Also look for The Lone Ranger's vampire parody *Barnabas in Collins Wood. DJ Round Up* is a serviceable compilation of early roots DJs, including performances by U-Roy, I-Roy, Jah Woosh, and Dillinger.

Out of the many British reggae acts that emerged during the '70s, the most critically successful was Steel Pulse, represented in this book by their 1979 LP *Tribute To The Martyrs* and the 1984 release *Earth Crisis.* Aswad, another British reggae group, shouldn't be overlooked, and their LP *Hulet* captures them in their early '80s prime. And while the UK's Third World have often been criticized by purists for their commercial tendencies, they've achieved considerable pop success, highlighted by their 1977 LP *96° Degrees In The Shade* and its chart-topping cover of "Now That We've Found Love." Another international reggae star was Alpha Blondy from the Ivory Coast; *Jerusalem* is one of a series of LPs heavily inspired by roots reggae he released during the mid-'80s.

DUB

Agrovators Meets The Revolutioners,
 The Aggrovators & The Revolutioners,
 1977
 LP: Third World, TWS-900 (UK)
 CD: Culture Press, CPCD-503 (France)
Aquarius Dub, Herman Chin-Loy,
 1973
 LP: Aquarius, AQLP-001 (JA)
 CD: Aquarius, AQCD-001 (UK)
Big Showdown: Scientist v. Prince Jammy,
 Scientist and Prince Jammy, 1980
 LP: Greensleeves, GREL-10 (UK)
 CD: Greensleeves, GRELCD-10 (UK)
Blackboard Jungle Dub, The Upsetters,
 c. 1979
 LP: Clocktower, LCPT-0115 (US)
 CD: Clocktower, CTCD-115 (Canada)
Dread Beat An' Blood, Linton Kwesi
 Johnson, 1978
 LP: Heartbeat, HB-01 (US)
 CD: Heartbeat, HB-001 (US);
 Frontline, CDFL-9009 (UK)
Garvey's Ghost, Burning Spear, 1976
 LP: Mango, MLPS-9832 (US)
 CD: with *Marcus Garvey,* Mango,
 PGDCD-539377 (US);
 Mango, RRCD-20 (UK)

Heavyweight Dub Championship, Scientist,
 1980
 LP: Greensleeves, GREL-13 (UK)
 CD: Greensleeves, GRELCD-013 (UK)
I Came I Saw I Conquered,
 The Revolutionaries, 1981
 LP: JJ, JJ-029 (US)
 CD: Hitbound, JJCD-029 (US)
Ital Dub, Augustus Pablo, 1975
 LP: Trojan, TRLS-115 (UK)
 CD: Clocktower, CTCD-0805 (US)
Jonkanoo Dub, The Revolutionaries, 1978
 LP: Hitbound, JJ-025 (US)
 CD: Hitbound, JJCD-025 (US)
Juk's Incorporation Part Two, Dub
 Specialist, c. 1975
 Studio One, DB-101 (JA)
Kamikaze Dub, Prince Jammy, 1979
 LP: Trojan, TRLS-174 (UK)
 CD: Trojan, CDTRL -174 (UK)
King Tubbys Meets The Rockers Uptown,
 King Tubby/Augustus Pablo, 1976
 LP: Clocktower, CT-0085 (US)
 CD: Clocktower, YHRCD-1055 (US);
 Shanachie, MESSCD-107 (UK)
Meditation Dub, Winston Riley, 1976
 Techniques (JA)
Original Rockers, Augustus Pablo, 1975
 LP: Greensleeves, GREL-8 (UK)
 CD: Greensleeves, GRELCD-8 (UK)
Outcry, Mutabaruka, 1984
 LP: Shanachie, 43023 (US)
 CD: Shanachie, SHCD-43023 (US)
Revolutionaries Sounds Vol. 2,
 The Revolutionaries, 1979
 Ballistic, UAK-30237 (UK)
Rockers Almighty Dub, Bunny Lee, c. 1978
 Clocktower, LCPT-0102 (US)
Schizophrenic Dub, Mad Professor, 1986
 LP: Ariwa, ARILP-030 (UK)
 CD: Ariwa, ARICD-030 (UK)
The Seducer, Scientist, 1982
 Channel One, LPJJ-082 (US)

In its most basic form, dub refers to the art of remixing a song so that most of its melody and lyric tracks are removed (or appear only sporadically), with the new emphasis placed on the song's rhythm section, the drum and bass. During dub's heyday in the late '70s and early '80s, studio geniuses like Lee Perry, King Tubby, Prince Jammy, and Augustus Pablo constantly tinkered with and reinvented the medium, creating a sparse, bass-heavy sound that would pave the way for such diverse styles as dancehall and dub poetry, and later even drum 'n' bass and hip-hop.

If it seems that this book has an abundance of dub albums, it's not your imagination. Most dub albums lacked lyrical themes that had to be addressed in the cover art, an absence that allowed reggae designers unbridled creativity when

working with dub artists. The result was a flood of dub LPs with exciting covers. Augustus Pablo in particular released several classic dub albums including *King Tubby Meets The Rockers Uptown, Original Rockers,* and *Ital Dub.* Pablo also contributed to one of the earliest dub albums, Herman Chin-Loy's outstanding *Aquarius Dub.* Other top dub producers were Bunny Lee with *Rockers Almighty Dub,* Winston Riley with *Meditation Dub,* Prince Jammy with *Kamikaze Dub,* Lee Perry with *Blackboard Jungle Dub* and *Garvey's Ghost,* Jack Ruby's classic dub version of Burning Spear's *Marcus Garvey.* Also check for *Schizophrenic Dub,* part of the wild series of dub LPs by UK dubmaster Neil Fraser, aka the Mad Professor. The Revolutionaries, Channel One's *de facto* studio band, released a string of dub albums with fantastic covers that celebrated reggae's Rastafarian and, not surprisingly, revolutionary, tendencies. *Revolutionaries Sounds Vol. 2* is the most prominent of these, followed by *Jonkanoo Dub* and *I Came I Saw I Conquered.* The Revolutionaries also teamed up with Bunny Lee's stable of all-star musicians, The Aggrovators, on several classic dub encounters, including the outstanding *Agrovators Meets The Revolutioners.*

At the opposite end of the spectrum were the covers for the dub albums of the studio whiz Scientist, whose sleeves played up reggae's comical side. Check for Scientist's showdown with Prince Jammy, *Scientist v. Prince Jammy;* one of his collaborations with the Roots Radics, *The Seducer;* and *Heavyweight Dub Champion,* produced by Henry "Jungo" Lawes.

Dub poetry, a lyrical offshoot of dub in which poets flowed over bass-heavy dub tracks, was particularly popular in the early '80s. The best examples in this book are Linton Kwesi Johnson's debut LP, the riveting *Dread Beat An' Blood,* and Mutaburaka's *Outcry.*

DANCEHALL

Badda Dan Dem, Lone Ranger, 1982
 Studio One, FCD-575 (JA)
Blasted, Chalice, 1981
 LP: Pipe Music, PMLP-001 (JA)
 CD: Pipe Music, PMCD-001 (US)
Bunny Wailer Sings The Wailers, Bunny
 Wailer, 1980
 LP: Mango, MLPS-9629 (US)
 CD: Mango, PGDCD-539629 (US);
 Mango, RRCD-8 (UK)
Dance Hall Showcase Vol. II, Sugar Minott,
 1983
 Black Roots, 10" LP, BRST-1002 (UK)
Dread At The Controls, Mikey Dread, 1979
 Trojan, TRLS-178 (UK)

Final Mission, Various artists, *c.* 1984
 Power House, LP-18693 (JA)
How The West Was Won, Toyan, 1981
 Greensleeves, GREL-20 (UK)
Hunter Man, Barrington Levy, 1983
 Burning Sounds, BS-1050 (UK)
Operation Radication, Yellowman,
 1982
 LP 10": Pama, PMLP-3215 (UK)
 CD: Nectar Masters, NTMCD-548
 (UK)
Poorman Style, Barrington Levy, 1983
 Clocktower, LCPT-0125 (US)
Road Block, Sammy Dread, 1982
 LP: Hitbound, JJ-068 (US)
 CD: Hitbound, JJCD-068 (US)
Rock 'n' Groove, Bunny Wailer, 1981
 Solomonic, LP-0013 (JA)
Rub A Dub Style, Papa Michigan & General
 Smilie, 1979
 LP: Studio One, SOL-1138 (JA)
 CD: Heartbeat, HB-3512 (US)
Show-down Vol. 2, Sugar Minott & Frankie
 Paul, 1983
 LP: Empire (US)
 CD: Hitbound, JJCD-160 (US)

*Sleng Teng Extravaganza: 1985 Master Mega
 Hits Volume 2,* Prince Jammy, 1985
 Jammys, J003 (JA)
Smashing Superstars, Various artists, 1983
 Vista Sounds, STLP-1015 (UK)
Something Fishy Going On, Ranking
 Ann, 1984
 Ariwa, ARILP-010 (UK)
Them A Mad Over Me, Yellowman, 1981
 LP: JJ, JJ-060 (US)
 CD: Hitbound, JJCD-060 (US)
Two Giants Clash, Yellowman versus Josey
 Wales, 1984
 LP: Greensleeves, GREL-63 (UK)
 CD: Shanachie, SHCD-48013 (US)

This book includes covers from the early days of dancehall, a period stretching roughly from the late '70s to the mid-'80s. Barrington Levy was one of dancehall's earliest stars; check out two of his LPs, *Poorman Style* and *Hunter Man.* Other outstanding albums by dancehall singers found in this book include Michael Prophet's *Righteous Are The Conqueror,* Sammy Dread's *Road Block,* and Sugar Minott's 10" *Dance Hall Showcase Vol. II.* The veteran Bunny Wailer also tried his hand at the dancehall style on LPs like *Rock 'n' Groove,* despite considerable criticism at the time. *Bunny Wailer Sings The Wailers* remains a revelation, as Bunny, with the help of groundbreaking producers Sly and Robbie, puts an indelible stamp on several Wailers' classics.

The dance hall was the true domain of the DJ, and DJs provided many of the most memorable albums from the dancehall era. The most popular and the most prolific of the DJs was Yellowman. While some of his output must be approached with caution, *Them A Mad Over Me* and the 10" LP *Operation Radication* offer justification for his popularity. Another wildly popular DJ act was Papa Michigan and General Smilie, well represented on *Rub A Dub Style.* Toyan's *How The West Was Won,* The Lone Ranger's *Badda Dan Dem* and *Smashing Superstars,* a compilation featuring such popular DJs as Eek-A-Mouse and Ranking Joe, are fine examples of the genre. Of special interest is an LP by the female British DJ Ranking Ann, *Something Fishy Going On,* which contains an admirable blend of microphone dexterity and politically conscious lyrics.

Dancehall also helped popularize the one-rhythm LPs, albums featuring the same rhythm on every track, with a new singer and DJ testing their skills on each cut. The compilations *Sleng Teng Extravaganza* and *Final Mission* represent two of the more successful examples of this phenomenon, employing the popular "Sleng Teng" and "Greetings" rhythms respectively.

Of the many DJ clash albums (which featured one DJ "battling" another), most noteworthy is the epic meeting of Yellowman and Josey Wales, *Two Giants Clash* and *Show-down Vol. 2* between Sugar Minott and Frankie Paul. *Show-down Vol. 5,* featuring Yellowman versus Purpleman, is not as essential, but how can you pass up that cover?

FURTHER READING

For those interested in further exploring reggae's music and culture, there are several books on the subject that can be recommended:

CATCH A FIRE: THE LIFE OF BOB MARLEY
Timothy White (London: Elm Tree and Corgi, *c.* 1983; revised edn, New York: Owl Books, 1996)
Probably the best known book on Bob Marley, it provides a thorough, if often fanciful look at the superstar's life.

DOWNBEAT SPECIAL
Rob Chapman (Paignton: self-published, revised, 1996)
The essential discography of Studio One Records. Available from Downbeat Special, PO BOX 98, Paignton, TQ3 2YJ, UK

BOB MARLEY
Stephen Davis (London: Arthur Baker, 1983, Panther, 1984; revised, Rochester, VT: Schenkman Books, 1990)
The other major Marley biography, slightly more straightforward than *Catch A Fire.* For proper balance and perspective, serious fans should read both.

BOB MARLEY—SONGS OF FREEDOM
Adrian Boot and Chris Salewicz (London: Bloomsbury; and New York: Penguin Studio, 1995)
With a presentation more reminiscent of a CD boxset booklet than a traditional biography, this heavily illustrated volume is the ideal introduction to the Marley legend. Boot's splendid photographs combine with a wealth of Marley and reggae artifacts to create a vivid background for Salewicz's text.

MORE AXE 8
Ray Hurford and Tero Kaski (Finland: Muzik Tree/Black Star, 1998)
The latest installment in Ray Hurford's reggae fanzine. For serious reggae fans, the series' in-depth interviews and profiles are a revelation.

A RASTA'S PILGRIMAGE—ETHIOPIAN FACES AND PLACES
Neville Garrick (Rohnert Park, CA: Pomegranate, 1999)
Although not focusing on reggae *per se,* Garrick's text and wonderful photos provide deep insights into Rastafarianism and its links with Ethiopia.

REGGAE INTERNATIONAL
Stephen Davis and Peter Simon (London: Thames & Hudson, 1983)
Hard to find, but well worth it. This is a gorgeously designed book, lavishly illustrated, that captures the world of reggae during the height of its popularity in the early '80s. It gives the religious, political and historical as well as musical context. Its sections on Rastafarianism, Marcus Garvey, and ganja provided crucial background material for this book.

REGGAE ISLAND—JAMAICAN MUSIC IN THE DIGITAL AGE
Brian Jahn and Tom Weber (New York: Da Capo Press, 1998)
Reggae in the '90s, through interviews with a wide range of artists, including Shabba Ranks, Big Youth, Buju Banton and Burning Spear. Required reading for dancehall fans.

REGGAE ON CD: THE ESSENTIAL GUIDE
Lloyd Bradley (London: Kyle Cathie Ltd, 1996)
An engaging and accessible guide to reggae available on CD.

REGGAE ROUTES
Kevin O'Brien Chang & Wayne Chen (Philadelphia: Temple University Press, 1998).
A thoughtful look at reggae from a pointedly Jamaican perspective, with particularly informative discussions on reggae's musical roots.

REGGAE—THE ROUGH GUIDE
Steve Barrow and Peter Dalton (London: Rough Guides, 1997).
The most comprehensive book available currently, and probably ever, on reggae, it chronicles reggae's complete history, and also features reviews of hundreds of LPs and CDs. It was an invaluable reference source for the research for this book. Strongly recommended for neophytes and reggae aficionados alike.

THE VIRGIN ENCYCLOPEDIA OF REGGAE
Colin Larkin (London: Virgin Books, 1998)
Part of Virgin's *Encyclopedia of Popular Music* series, and, while not nearly as thorough as The *Rough Guide,* it does contain handy reviews of hundreds of reggae albums.

INDEX

*Page references in italics list
captions to the illustrations*